Contents

The vegetables

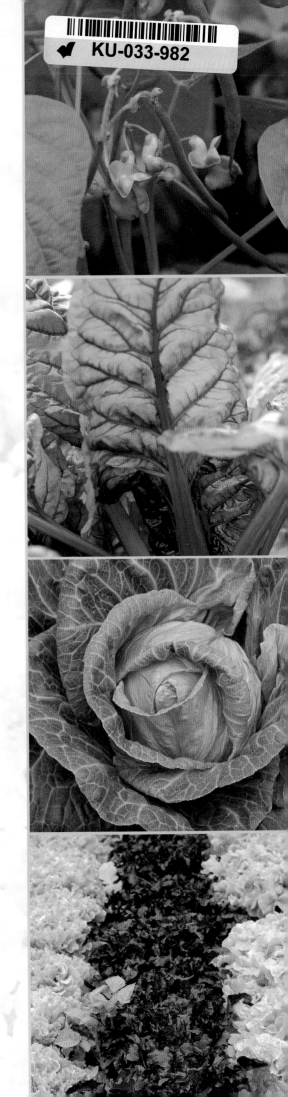

Introduction

Growing vegetables is back in fashion, and it is not difficult to see why. It's a rewarding, productive hobby, out in the fresh air, and it's something all the family can get involved with. Nothing can beat the flavour and nutritional value of fresh organic produce, especially if it has only to travel up the garden path from plot to plate – assuming, of course, that it even gets that far!

Organic methods encourage recycling and the use of recycled products, and promote wildlife by creating habitats for a diversity of natural creatures to keep pests and diseases under control rather than using pesticides. It is not surprising, therefore, that as people become increasingly concerned about mass food production methods, environmental pollution and waste disposal, organic methods of growing food are becoming more and more popular.

If you have never grown vegetables before, getting started can be a bit daunting, especially if you are fairly new to gardening. But you don't have to be an expert or have a large garden to grow vegetables. This book will tell you, clearly and simply, all you need to know to start growing vegetables organically, whether you have a large garden, a small suburban patch or just a few tubs and a window box. It will help you choose what you're going to grow, how and where to grow it, and how to keep pests and diseases at bay without using chemicals. There is also clear advice on preparing and looking after the soil – a vital starting point for growing organic vegetables. If you have never grown anything before, organic gardening methods will probably seem the most logical and sensible way to garden. After all, plants grow in nature without any human intervention whatsoever. Organic gardening is basically about using, and improving upon where necessary, the basic natural processes that make all things grow.

Frilly lettuces and parsley make an attractive edging for a bed of vegetables, or even flowers.

Grow your vegetables organically, for health and flavour.

Dwarf French beans hanging up to dry. Once podded, the seeds can be saved to sow the following season, or eaten in soup or stew.

4

The ... de to
Gr... ples

SEARCH PRESS

First published in Great Britain 2008
Search Press Limited
Wellwood, North Farm Road,
Tunbridge Wells, Kent TN2 3DR

in association with:
Garden Organic
Garden Organic Ryton
Coventry CV8 3LG
www.gardenorganic.org.uk

Text copyright © 2008 Garden Organic
Design copyright © 2008 Search Press Ltd.

Photographs copyright © 2008 Charlotte de la
Bédoyère (pages 2, 3, 4, 5t, 7t, 8, 9t, 10t, 10m,
10b, 11t, 11m, 12b, 13tl, 14t, 14m, 15, 16, 18, 19t,
19m, 21tm, 22, 23t, 24b, 26, 27, 28tr, 28tl, 28tm,
28br, 29t, 29br, 30, 32t, 33r, 35, 36t, 36m, 36br,
37t, 37b, 38, 39b, 40tl, 40tr, 41t, 41m, 42t, 42m,
43, 45, 46t, 46b, 47, 48, 50, 51, 52, 53, 54, 55, 56t,
56b, 57m, 57bl, 57br, 58, 59m, 59b, 60, 61t, 62 and
63); Pauline Pears (pages 1, 5b, 6, 7b, 9b, 13tr, 14b,
17, 19b, 20, 21tr, 21tl, 21mr, 21bl, 21br, 23b, 24t,
25, 28bl, 29bl, 31, 32m, 32b, 33l, 34t, 36bl, 37m,
39t, 40b, 41b, 42b, 44, 46m, 49, 56m, 57t, 59t and
61b), Colin Shaw (page 13b); The Recycle Works
Ltd, Clitheroe, Lancashire (page 11b); and Chantal
Roser (pages 12m and 34b).

ISBN: 978-1-84448-088-3

Printed in Malaysia.

Dedication

To Roger Pears, who grew wonderful
vegetables, and to his granddaughter, Katherine
Elizabeth Pears, who will do too.

Acknowledgements

I would like to thank all my colleagues at
Garden Organic, and those who have moved
on to pastures new, for their support and
assistance in producing this book.

If, in the past, you have used artificial fertilisers and pesticides, you will need to convert your garden, and perhaps your mindset, to organic methods. There is nothing complicated about this – you simply start using positive, organic practices, as outlined in this book, and stop using pesticides, artificial fertilisers and other products that are not suitable for an organic garden. Depending on its current state, it may take a year or two for your garden to readjust to the new regime. For the best results, use organic methods in all areas of the garden, not just the vegetable patch.

The most important place to start is with the soil. Soil isn't just 'dirt' – it's a complex ecosystem, as full of life as the environment above ground, and has a huge impact on the growth and health of our plants. A healthy soil will grow healthy, nutritious plants; organic food contains, on average, higher levels of vitamin C and essential minerals such as calcium, magnesium, iron and chromium, as well as cancer-fighting antioxidants, than non-organic food.

There can be some confusion about what garden products are suitable for use in an organic garden, particularly as there is no legal definition of the word 'organic' in relation to gardening as there is in farming. More information, and a detailed set of organic gardening guidelines, can be found on the Garden Organic website – www.gardenorganic.org.uk. Garden Organic is the UK's leading organisation for organic gardeners.

The asparagus pea is low growing, with red flowers and small, winged pods.

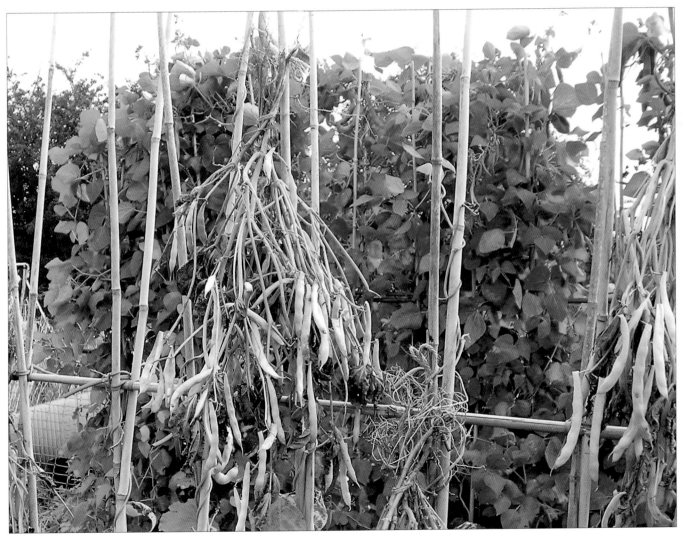

Before you start

Before putting spade to soil, take time to think about what vegetables you want to grow, and where would be a suitable spot to grow them.

Sun or shade?

Most vegetables need full light for at least six hours a day, though a few will grow in shadier conditions (see page 16). Avoid sites that are close to a large tree or hedge as these can deplete the soil of moisture and nutrients, and shady walls or overgrown corners can harbour slugs and snails, so avoid these too.

Ground or pots?

Not everyone will have soil in a location suitable for vegetable growing. You may decide to convert part of the lawn, or consider an allotment. There are also numerous vegetables that grow well in containers (see pages 15 and 32–63).

Rows, beds or flowerbeds?

You may choose to grow your vegetables in rows in a traditional vegetable plot, or you may prefer to grow them in beds. Alternatively, just slot some vegetables in amongst your shrubs and flowers. See pages 12 and 13 to help you choose.

How good is the soil?

You can tell a lot about your soil by looking at the plants already growing in it. How well are they doing? A healthy crop of weeds is usually a good sign. If the plants are not thriving, or if there is nothing growing at all, it is worth taking a closer look, as there are plenty of ways to improve a poor soil (see pages 7–11).

What's the soil type?

Knowing what type of soil you've got can help you grow vegetables more successfully. Basically, most soils range from sandy to clay. The sandier a soil, the more quickly it will warm up in the spring, the easier it is to dig, the quicker it drains, and the less naturally fertile it will be. Heavy, clay soils have the opposite characteristics. Timing is much more critical when growing in sticky, heavy soils, but they are potentially much more fertile.

To find out what type of soil you've got, take a handful of moist soil. Knead it well and rub it between your fingers. If it feels a bit gritty, it is a sandy soil; if it doesn't feel gritty, but does feel sticky, then it is a clay soil.

How acid is it?

Soils can be acid, neutral or alkaline. Vegetables prefer a soil around neutral – so if you are growing on ground that is new to you it is worth measuring the acidity. You can do this with a test kit (known as a pH test kit), which is available from garden centres. Acid soils can be made more neutral by adding ground limestone. Highly alkaline soils can be the result of a previous owner using too much lime, in which case the soil will gradually become more neutral over the years without you having to do anything.

Getting started

Whatever is currently growing where you have chosen to grow your vegetables, it needs to be removed. There are various ways of doing this:

Dig out the plants using a spade or fork, taking care to remove as much root material as you can. You may need to go over a very weedy plot several times.

Weedy soil or a lawn can be cleared by covering the area with a light-excluding mulch. Cut down the vegetation and cover it with black plastic or flattened cardboard cartons held down with bricks, wood or straw. After a few months, the top vegetation will have died back. If there are still bulky roots in the soil, leave it for another few months, or dig the soil over to remove them.

Tools Starter Set

Spade
Fork
Hoe
Trowel
Watering can
Rake
Bucket/tub for collecting weeds in
Compost bin

Tip!

When buying a rake, hoe, spade or fork, handle it first. Make sure the handle is long (or short) enough. Check the weight – a spade or fork full of soil adds a lot of weight which you might find difficult to lift.

Preparing the soil

You won't need to dig regularly, but it is worth giving the soil a good initial dig when starting off a new vegetable patch. Apart from anything else, you get to know a bit more about what is going on underground.

- When digging, try not to mix the darker, fertile topsoil with the paler subsoil.
- If the soil sticks to your spade or your boots, it means it's too wet to dig.
- Avoid walking on ground that you have just dug.
- Don't dig soil when it's very dry.

If the soil is in good condition, with no compacted layers, you can get started without any digging at all (see page 14)!

What next?

You may need to add soil improvers and organic fertilisers before you start (see pages 8 and 9). If there are already healthy plants growing, then you may have very little to do. The ground under a lawn is usually pretty fertile. Ground that is full of shrubs and ornamental plants may need more attention. See pages 8–11.

Double digging

This is useful for breaking up new ground, or compacted layers. It improves subsoil without bringing it to the surface. Dig a trench 60cm wide and a spade deep and put the soil in a wheelbarrow. Loosen the soil in the bottom of the trench by sticking a fork into it and moving it backwards and forwards. Do this every few centimetres along the bottom of the trench. Dig another trench next to the first one, filling the first trench with the soil from the second. Loosen the bottom as before. Fill the final trench with the soil from the barrow.

Looking after the soil

If the soil is in good condition, plants will thrive. Caring for the soil, and the tiny creatures that live in it, is the key to growing healthy crops. Avoid doing anything that can damage the soil, and use organic methods to maintain and improve its condition. Remember that organic vegetables get all the nutrients they need from the soil, and from the organic soil improvers and fertilisers you may add to it. These are made available to the growing plants by the actions of the creatures living in the soil.

How to keep your soil in good condition

- Keep it covered with growing plants or a mulch.
- Don't walk on it more than you need to.
- Only dig if necessary.
- Don't dig when the soil is too wet or dry.
- Apply bulky organic soil improvers.
- Grow green manure cover crops (see page 27).
- Lime only if necessary. Too much lime, or over-fertilising, can be as bad as too little, altering the balance in the soil and making some nutrients unavailable to the growing plants.

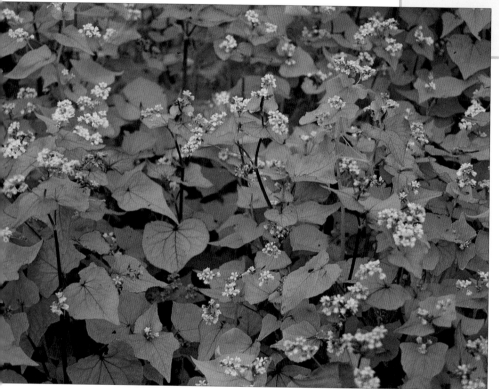

Buckwheat is an example of a 'green manure' – a plant grown to protect bare soil, smother weeds and build soil fertility (see pages 11 and 27).

TIP
If you don't want to use any animal-based products, there are plenty of organic, animal-free alternatives.

Bulky organic soil improvers

Bulky organic soil improvers such as garden compost, leafmould and animal manures are the key to maintaining a healthy soil. You may be able to make some of these yourself using waste from your own garden, but if not there are plenty of other sources.

Some soil improvers are richer in plant foods than others, so which ones you use depends on the vegetables you are growing (see the vegetable pages, 32–63) and the quality of the soil. Potatoes, for example, need a fair amount of food, so a well-rotted manure is ideal for them. It will also help the soil hold moisture as the crop grows. Carrots, on the other hand, can make do with the leftovers from a previous crop, but can benefit from a low-nutrient soil improver such as leafmould to lighten the soil and help it hold moisture.

Benefits of bulky organic materials

- Improve light and heavy soils.
- Feed the creatures in the soil that keep soil healthy, and in turn feed the plants.
- Save water and watering.
- Help limit soil-living pests and diseases.

High nutrient value soil improvers

Well-rotted animal manure can be obtained from stables and farms, but it needs to be processed at home. Use up to one full wheelbarrow load (approximately 50 litres) per 5 square metres. This is a layer around 0.5cm deep. Apply in spring and summer only.

Medium nutrient value soil improvers

These include **garden compost, green waste compost, mushroom compost, grass mowings** (but not mowings from lawns that have been treated with weed killer). Mushroom compost can be obtained from mushroom farms. It contains chalk, so it shouldn't be used on alkaline soils. Use up to three full wheelbarrow loads per 5 square metres. This is a layer around 1 to 1.5cm deep. Apply in spring and summer only.

Low nutrient value soil improvers

Leafmould (use fallen autumn leaves), **straw** (old straw from farms and stables is best; processed straw mulch is available from shops) and **fine-grade bark.** Apply in a layer up to 15cm deep; heavy materials that pack down, such as leafmould, should be applied up to 10cm deep.
Can be applied all year round.

Chicken manure is very rich. Process it through a compost heap; do not add it directly to the soil.

Green waste compost is made from the compostable material taken to recycling sites. Strict quality control means it is safe to use in any garden. It releases its nutrients slowly and is a good source of potash.

Some examples of organic fertilisers

Pelleted chicken manure – for potatoes and other greedy feeders (vegetables that need a lot of nutrients).
General organic fertiliser for vegetables – containing blood, feather meal, cocoa shells, seaweed meal, vinasse (a waste product of the sugarbeet industry).
Organic potato fertiliser – as above, but with more potassium.
All-purpose fertiliser for vegetables, without animal products – rapeseed and soybean meal, kelp, lignite, rock phosphate.
Seaweed meal – rich in trace elements.
Comfrey pellets – for potatoes and tomatoes.

Organic fertilisers

Organic fertilisers are natural materials of plant, animal or mineral origin, for example rapeseed meal, bone meal and rock phosphate. Unlike chemical fertilisers, which act quickly, the nutrients in organic fertilisers are slowly made available to the plants as they are broken down by the creatures living in the soil. They are something like wholefoods in a human diet, whereas chemical fertilisers are like fast-foods.

Organic fertilisers can be bought for general vegetable growing, or for specific vegetables such as tomatoes or potatoes. They should not be used instead of bulky organic soil improvers, which should always be the first choice, but they work well when combined with low-nutrient, bulky material such as leafmould.

Making garden compost

Garden compost is a great organic soil improver. It can also help to control pests and diseases in the soil, and make plants more resistant to attack. Compost is easy to make at home by recycling plant waste in a compost heap. Make your compost heap in an accessible spot, either directly on the ground (covered with a plastic sheet) or in a compost bin. If you're using a bin, place it directly on the ground for drainage. Add suitable ingredients to your compost bin as they become available. The more you add at once the better. Chop up bulky items or put them through a shredder if you have one before adding them to the heap.

The key to making good compost is to include a mixture of different types of material. Wet, soft, sappy materials, such as grass mowings and vegetable scraps, rot quickly but don't have enough fibre to make compost on their own. Tougher, older, drier ingredients, such as old plants and weeds, are slow to rot, but give the compost structure. Combine the two in roughly equal amounts to make good compost. Most households tend to produce more of the softer material, so keep to hand waste paper and cardboard, and perhaps a few sacks of autumn leaves, to balance the mixture.

Compost is usually made in a compost bin. You can make your own, preferably out of recycled materials such as old pallets, straw, chicken wire, and so on. A compost bin has no base, but does need a lid or a cover. You can also buy compost bins made from recycled plastic or wood. Choose one that suits your style and your garden.

DO COMPOST

Grass mowings

Weeds

Fruit and vegetable scraps

Teabags and coffee grounds

Straw-based manures

Old flowers and bedding plants

Young hedge and shrub clippings

Gerbil, hamster and other vegetarian pet bedding

Vegetable plant remains

Autumn leaves (not in bulk)

Shredded woody prunings (not in bulk)

Cardboard, paper towels, bags and packaging (scrumple up into loose balls before adding to the heap)

Cardboard egg boxes and tubes

Roots of perennial weeds – compost in a separate heap to ensure that they are completely rotted before using in the garden. Alternatively, put tricky weeds such as ground elder and bindweed in a lightproof sack for six months to rot before adding them to the compost heap.

DON'T COMPOST

Cooked food

Meat and fish scraps

Coal and coke ash

Cat litter, used

Disposable nappies

WON'T COMPOST

Tins

Plastic bottles and bags

Glass

Crisp packets

Milk cartons

Maintaining your compost heap

Every few months, remove the bin from the compost (or remove the front if that's the sort of bin you have) and check what is happening. You may be quite surprised. The bottom layers of the heap will look like dark soil, with none of the original ingredients (apart perhaps from eggshells or corn cobs) identifiable. This is ready-to-use compost. Mix together the remaining uncomposted and semi-composted materials and replace them in the bin. At this point you can adjust the mixture if necessary. If it seems rather dry, mix in some more green ingredients for moisture. If rather wet and smelly, mix in some tougher stuff.

Composting ingredients will shrink as they decay, so you may be able to carry on adding material and removing it without the bin ever getting full. If it does fill up, then just leave the materials in it to decay, and start another heap.

Leafmould

Autumn leaves rot down to make an excellent soil improver called leafmould. Leafmould is simple to make; the leaves are light and easy to handle, and a new supply falls from the trees every autumn.

1. Collect up deciduous (not evergreen) leaves in the autumn.
2. If the leaves are dry, water them with a hose.
3. Stuff the leaves into black plastic sacks (tied loosely at the top), or into a simple wire-mesh cage to stop them blowing away.
4. Wait for a year then use the leafmould as a mulch; if it is well rotted, it can also be dug into the soil. Leaves can be left for another year to rot down completely.

Straw-based animal manures

Straw-based cattle, horse or poultry manures are a rich source of organic matter and plant foods. Ideally they should come from an organic source; definitely avoid manures from intensive farming systems. Stack manure in a heap under a plastic cover for six months so it is well rotted before using it. This also gives time for any pollutants to decay.

Worm composting

A worm bin is an ideal way of composting if you have a very small garden. Compost worms are kept in a suitable container, such as a converted dustbin or a purchased, purpose-made container, and fed regularly. They cannot deal with large quantities at once, but may keep going all winter if fed regularly. They will convert kitchen scraps into a rich, spongy compost that can be added to home-made potting mixes, and used for top-dressing container-grown vegetables.

Green manure cover crops

Green manure cover crops are grown to protect and improve the soil. You simply sow the seeds, let the plants grow, then dig them back into the soil when you need to use the ground. Chop the foliage with a spade, then dig the plants into the top 20cm or so of soil, chopping again as you go. Green manures can be grown over winter, protecting the soil from the weather, and keeping weeds under control. They can also be grown on any patch of unused soil in the summer. Winter tares, buckwheat, phacelia and grazing rye can all be used as green manures (see page 27).

A section through a compost heap.

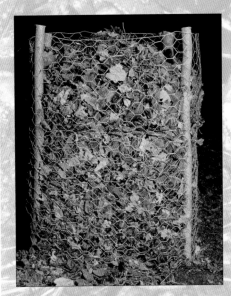

Make leafmould in a wire-mesh cage to stop the leaves blowing away.

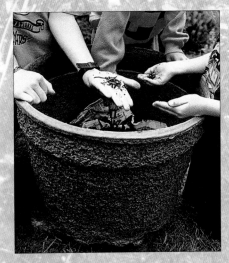

A worm bin.

Ways of growing vegetables

Traditionally, vegetables were grown in their own plot, often hidden away at the bottom of the garden. These days, gardens are often too small to have a separate vegetable patch, let alone one hidden away. Fortunately, there are many other ways that we can grow vegetables, so they can be fitted into even the smallest of gardens.

The traditional plot

This type of plot is suitable for larger gardens and allotments. It consists of a square or rectangular plot, often divided into four quarters for crop rotation (see page 25). Vegetables are grown in rows that you can walk between.

Growing on beds

A bed is simply an area of soil, ideally about 1.2m wide so that you can reach the middle from the path. Beds are particularly suitable for small gardens as they make good use of space and look neat and tidy. You need to leave paths around the beds for access, allowing enough space to be able to move around and work comfortably, and for turning a laden wheelbarrow. The soil on the beds is prepared in the usual way, but as the beds are not walked on, there is often no need for further digging.

Edging gives beds a neat appearance and helps prevent soil moving on to the paths, but it is not essential. Materials can be costly, though using recycled materials reduces the cost, and edging can be a magnet for slugs, so some people prefer not to use it. Suitable materials for edging include scaffold planks, new railway sleepers (not those treated with creosote), recycled wood such as floorboards, new wooden planks (wood such as larch will last much longer than pine), synthetic 'wood' made from recycled plastic, and purpose-made bed edgings made from recycled plastic.

Vegetables, such as these runner beans, make an attractive garden feature, particularly when grown in edged beds.

It is important to keep the paths between the beds free of weeds. Some people have grass paths, but the grass can compete with the growing vegetables for food and water, and needs to be cut. The simplest alternative is to leave the paths bare, and hoe them regularly, but they can get very muddy. A practical alternative is to mulch the paths with a 15cm (6in) or more layer of woodchips or ornamental bark, preferably over a permeable synthetic membrane to prevent weeds emerging from the soil. Alternatively, lay paving slabs.

Raised beds

Raised beds are built up using soil brought in from somewhere else. They are useful if drainage is poor or the topsoil is thin.

Raised beds can be constructed from planks of timber, though make sure it has not been pre-treated with a non-organic wood preservative which may leach out into the soil.

This easy-to-construct raised bed kit (there are several types on the market) can be placed directly on the soil, or even on a patch of lawn, and filled with soil or potting compost. This is an easy way to get started with a few vegetables in your garden.

The 'square foot' garden

A tiny vegetable plot in the form of the square foot garden means even the smallest plot of land can be used for growing vegetables. It is simply a 1.2m (4ft) square raised bed, approximately 15cm deep, marked out into sixteen squares (each a square foot) using a grid of string or nylon line. Each square, only 30cm (12in) square, supports a different sort of vegetable. It's amazing how much you can fit in! Choose varieties that can be grown close together, or can be picked over regularly. 'Mini' varieties, highlighted in many seed catalogues, are particularly suited to this way of growing.

What you could grow in each 12-inch square of your 'square foot' garden

4 parsnips
4 leeks
4 Little Gem lettuces
4 loose-leaf lettuces
4 garlic plants
16 carrots
16 onions
9 French beans
4 parsley plants
4 chard plants

And of course you can fill a square or two with a herb or flower; and have more than one bed!

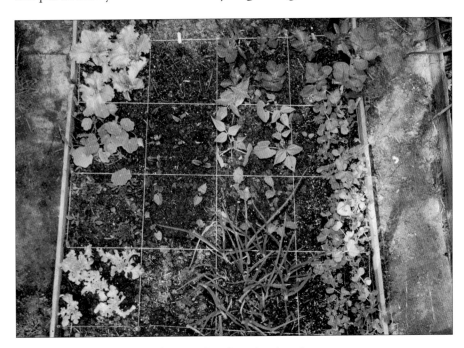

A 'square foot' garden, a few weeks after planting the crops.

The potager look

If you don't want to use an area of your garden solely for growing vegetables, you can slot them in amongst flowers and shrubs. Many vegetables make attractive plants and don't look out of place in an ornamental border. Crop rotation is still important – avoid growing the same vegetable in the same spot year after year, and make sure that both vegetable and flower plants have enough space to grow, and enough food and water. Remember that vegetables generally need a richer soil than annuals and shrubs.

Courgette flowers, leaves and fruit all have an 'ornamental' quality.

Curly kale is an unusual, but striking, addition to a flowerbed.

Some potager suggestions

- A wigwam of climbing beans. French beans, less vigorous than runners, can share their wigwam with an annual climber such as firecracker vine.
- Pumpkins trained up a trellis.
- Purple-flowered and podded peas grown over an arch in place of sweet peas.
- Loose-leaf lettuces, or parsley, make an attractive edging.
- Rainbow chard can outshine most flowers.
- Courgette plants make a striking feature, and their vivid yellow flowers are stunning.

'No dig' gardening

'No dig' gardening means just that – gardening without digging. All soil improvers and fertilisers are applied to the soil surface, at the usual rate. Seeds are sown into drills, and transplants go into trowel holes. Root crops may need to be loosened with a fork for harvesting, but the ground is never turned over.

When starting a 'no dig' garden on a new site, it is important to check out the soil conditions (see pages 6 and 7), clear any weeds using light-excluding mulches (see pages 26–27), and, if necessary, dig the plot to break up any compaction. After that, there is no need to dig at all.

On this 'no dig' vegetable patch, potatoes are 'planted' on the soil surface and covered with straw.

Growing vegetables in containers

Many vegetables can be grown in pots, planters, troughs, boxes and other containers, so even if you have only a small patio or a sunny window box, you can still grow vegetables of your own.

Your choice of container is almost limitless, as long as it has drainage holes in the bottom, is a suitable volume and depth for the plants you want to grow, and is sturdy enough to hold the compost and plants. A larger container is easier to look after than several small ones. Unglazed clay pots are attractive to look at, but they do dry out more quickly than others. Tall-growing plants will need a heavy container to stop them blowing over, but on the other hand a large tub full of compost can be heavy to move.

Filling the container

Fill the bottom of the container with a thick layer of 'crocks' such as polystyrene, large gravel or broken-up clay pots to aid drainage. Fill the container with moist, peat-free, organic multipurpose or potting compost. For larger containers, mix in some good quality soil with the potting compost. To reduce the amount of watering needed, add an organic moisture retainer such as coarse seaweed meal to the compost before putting it in the pot. Worm compost is also an excellent source of nutrients and is moisture holding.

Settle the compost, then firm it down gently. Aim for a final level (once the plants have been added) 6cm below the rim of the pot. This will make watering and feeding easier. Add the plants – either sown direct or transplanted. Water well.

After-care

Protect tender plants, such as tomatoes, peppers or basil, from cold and wind. If necessary, keep containers under cover in a warm, light space until the weather has warmed up. Water your plants regularly, more than once a day in hot, dry weather. Soak the compost well so water drains out of the bottom of the container. Don't let it dry out; it is very difficult to re-wet dry compost. If the container is sitting in a drip tray, make sure that it doesn't sit in water. Tie up and support plants if necessary. Keep an eye out for pests and diseases, and pick off pests and diseased leaves.

After a month or two, you may need to start feeding the crops. Apply a rich compost, such as worm compost, or comfrey pellets, to the surface of the compost in the container. Alternatively, use an organic liquid feed, following the instructions on the bottle.

A half-barrel makes an easy-to-care-for container for vegetable growing.

Advantages of container growing

- Makes an attractive feature.
- Vegetables can be grown where there is little or no soil, or poor quality soil.
- Different sorts of vegetables can be grown together.
- Soil problems, such as disease or poor drainage, are avoided.
- Tender vegetables, such as tomatoes, can be placed in sheltered sites.
- Slugs can be kept at bay.
- No need to worry about crop rotation.
- Plants can be given a head start by keeping containers under cover until the weather warms up.

Disadvantages of container growing

- Containers need regular watering – two or three times a day in very hot weather.
- Additional feeding is usually required.
- Not really practical for vegetables with a long growing season.

Tomato plants need support as they grow. These spiral supports are very effective, and look good too.

What to grow

One of the delights of growing your own vegetables is the huge choice of varieties available – way beyond anything you would see in any shop! But don't get carried away – if you are new to vegetable growing, start with just a few crops and varieties. This section will help you decide which vegetables to grow, and to select the right types – refer to pages 32–63 as well to help you make your choice.

What do you (and your family) like to eat?

It is always best to start with what you know you like before trying something new. Some vegetables almost always have a better taste when home grown – sweetcorn, purple sprouting broccoli, mixed salad and French and runner beans, for example. Varieties may differ in flavour, or be better suited to particular ways of eating. Tomatoes, for example, can be cherry sized with thin skins for eating whole straight from the plant, or beefsteak, which are good for salads. Pea pods can be eaten whole, or podded out. Some potato varieties are good for roasting, others for salads, and some are all-rounders.

Where do you live?

Tender crops such as tomatoes, courgettes and sweetcorn can't be grown outdoors everywhere in the country. Peppers and aubergines need even warmer conditions. If your growing site is prone to frost, cold summers, wind, etc., it is better to concentrate on hardier vegetables. For cooler climates, look for quick-growing varieties, often marked as 'early'.

Some lists to help you choose

Winter cropping

- Leeks
- Cabbage
- Brussels sprouts
- Sprouting broccoli
- Oriental greens
- Spinach beet
- Chard

Very quick return crops

- Saladini
- Loose-leaf lettuces
- Pak choi
- Summer radishes

Climbers

- Runner beans
- Climbing French beans
- Pumpkins (with assistance!)
- Tall peas

Shade tolerance

Vegetables that will tolerate light shade in summer, as long as there is sufficient food and water:
- Beetroot
- Calabrese
- Chicory
- Endive
- Kale
- Lettuces
- Peas
- Spinach
- Radishes
- Chinese greens

Ornamental and edible

- Climbing beans
- Chard
- Lettuces
- Beetroot
- Courgettes

Successional sowing

Vegetables that are best sown in relatively small quantities, several times through the growing season, to give a regular supply of fresh produce:
- Lettuces
- Rocket
- Spinach
- Dwarf beans
- Baby beetroot
- Salad mixes

Container growing

- Tomatoes
- French beans
- Chard
- Lettuces
- Spinach
- Baby leaf crops (see page 51)
- Potatoes

Quick returns

Some vegetables, for example mixed salads and oriental saladini, can provide something to eat within three weeks; other crops (kohl rabi, summer calabrese, spinach, summer leeks, spring onions, baby beetroot and oriental brassicas) will provide something more substantial in six to twelve weeks if you sow a quick ('early', 'baby' or 'mini') variety. Some plants, on the other hand, take many months to produce a crop.

Plant families

Choose crops from at least three or four different plant families rather than just one or two, so you can rotate your crops (see page 25).

Growing at home or on an allotment?

A garden is ideal for crops that need regular attention – particularly harvesting, for example courgettes, runner beans, lettuces or corn. If you are growing on an allotment that you don't visit very often, grow crops that can stand some neglect and don't need to be regularly harvested, such as onions, garlic, potatoes, drying beans and pumpkins.

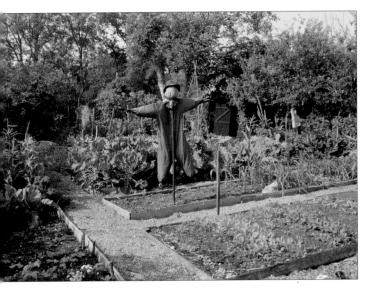

Make your vegetable plot or allotment a pleasant place to be.

Growing space

If space is limited, or you are growing in containers, avoid crops that produce large plants with a long growing period such as Brussels sprouts, broccoli, winter cabbage and cauliflower. Look for dwarf or compact varieties; you might also prefer some of the more ornamental types. French and runner beans, peas and pumpkins all have varieties that can be grown up canes, a trellis or a fence.

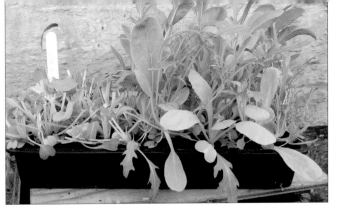

Oriental saladini growing in a seed tray. The plants on the left-hand side have been cut as a mixed salad.

Self sufficient?

If you are hoping to harvest something fresh almost all year round, start your choice with crops that can be harvested in winter and spring. It is all too easy to fill up your plot with vegetables that crop in the summer and autumn, forgetting to leave space for those vital winter crops. The 'hungry gap' tends to be in April and May, when winter crops have finished and the new season's are just starting to grow. You can also grow 'main-crop' varieties that store well over winter – onions, garlic, potatoes, drying beans, pumpkins, carrots, parsnips and beetroot, for example; these can be augmented with frozen produce. There are specific French bean varieties to grow for drying.

Soil conditions

Most crops will grow on most soils, but some, such as carrots, are fussy. Check on the conditions required in the vegetable section, pages 32–63.

Size of plants

You need to think about the plants' height and spread, particularly where space is limited. Different varieties of the same crop can vary widely in the space they take up. Tomato plants can be 2m tall, or a tumbling bush; pumpkins can spread for miles, or be a relatively compact plant.

Resistant varieties

If you know there is a regular pest or disease problem and you want to avoid it, try resistant varieties. These are not immune, but can help. Varieties with some resistance to carrot root fly, lettuce root aphid, potato blight, cucumber mosaic virus (of courgettes) are available. Check your seed catalogue for details.

F1 hybrids

You will see some variety names with the symbol 'F1' beside them. These are modern varieties that have been bred for performance and uniformity, and can perform very well. The down side is that the plants tend to be ready to harvest all at the same time.

Sowing seeds

Most vegetables are grown from seed, either sown directly into the soil outdoors, or in pots and trays for planting out when the plants are large enough. Organically grown seed is available for many vegetables. Potatoes and garlic are planted as potato tubers or garlic cloves, and are never started from seed. Onions and shallots can be sown as seed, but planting tiny bulbs known as 'sets' is often easier.

Hardy crops, such as early beetroot, carrots and broad beans, can be sown in spring, as soon as the soil conditions are right. Make sure the ground is not too wet to make a decent seedbed, and the soil temperature should be at least 7°C.

Tender crops, including tomatoes, pumpkins, sweetcorn and French and runner beans, need a much warmer soil to germinate and grow. This is why they are often started off in pots or trays indoors. Alternatively, you can buy organic transplants (see page 20).

Direct sowing

A week or two before you intend to sow, apply any soil improver or fertiliser your soil might need.

Beans direct!

Bean seed is the easiest to sow. Simply dig a tiny hole with a trowel and pop the seed in.

1. Firm the soil gently with the back of a rake. Level the soil, then rake it over gently to form a fine tilth, free of lumps. The smaller the seed, the finer the tilth required.

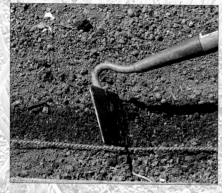

2. Mark out the length of the row with a string stretched tightly between two sticks. Using a rake or a hoe, take out a shallow drill (a V-shaped depression) alongside the string.

3. If the ground is dry, water along the bottom of the drill.

4. Place the seeds along the bottom of the drill (see pages 32–63 for distance between seeds). Small seeds should be buried no deeper than twice their size. Peas are sown at 2.5cm, beans at 4cm.

5. Cover the seeds with soil or fine compost.

6. Rake the soil back into the drill and tamp it down gently with the back of a rake. Don't water again until the seedlings emerge.

TIPS

- Don't be tempted to sow too early. Seedlings that are slow to germinate and grow are more likely to be eaten by slugs and other pests. A later sowing will often do better than one that was made too early.
- Warm up the soil before sowing outside with cloches, or clear or black plastic sheeting.
- Grass tends to start growing when the soil temperature is suitable for sowing hardy crops.
- If the soil is poor and tends to set hard when dry, mix some leafmould with it and use this to cover the seeds. Alternatively use potting compost.

Labelling

It is a good idea to label the end of a row with the variety name and sowing date. Pencil will last well on a plastic label and can be scrubbed off for re-use.

Thinning

Thinning involves remove unwanted seedlings until you are left with plants at the correct spacing. Start thinning out as soon as the seedlings are large enough to handle. The thinnings of some crops such as lettuces, oriental greens and even carrots can be eaten.

Station sowing

Sowing seeds at their final spacing, rather than placing them evenly along the row and then thinning, is known as station sowing. This is a particularly good method for widely spaced seeds, as less thinning is required and less seed is wasted. Place two or three seeds at each station, thinning to one plant when the seedlings emerge.

Broadcast sowing.

Broadcast sowing

Broadcast sowing can be used for patches of salad greens and for green manures. Sprinkle the seed evenly over prepared soil, then gently rake it in, first in one direction, then in the other. Tamp the soil down gently.

Stale seedbeds

A stale seedbed is a useful way of preparing weedy soils before sowing a crop. Simply prepare the soil, water it if it is dry, and leave it for a couple of weeks. Before sowing, gently hoe off the flush of weeds that will have appeared.

Hoeing off seedling weeds on a stale seedbed.

Raising transplants

The alternative to direct sowing is to raise transplants. Transplants are young plants that have been grown from seed, indoors or in a greenhouse, in pots and trays. Although direct sowing may be simpler, there are advantages to using transplants, and you can always buy young plants if you don't have the time, or the space, to grow your own. Organic vegetable transplants are available by mail order.

To raise plants successfully, you need two things:

1 Warmth

An airing cupboard can be a good location to start seedlings that need warmth. Check the seeds every day, and remove the pots or trays as soon as the first seedlings appear. Alternatively, use an electric propagator or heated mat.

2 Light

Once the seedlings appear, good light is essential, preferably coming from above and all round. If the seedlings are on a windowsill, use boards covered with reflective tinfoil to increase light levels. Take care that seedlings do not scorch in a south-facing window, or freeze behind a curtain closed for the night. Remember that tender plants will need warmth as well as light.

Advantages of raising transplants

- Crops get a head start. Plants can be growing indoors before conditions outside are suitable for sowing.
- It is easier to keep tender seedlings away from pests.
- Seeds can be sown whatever the weather, even on a wet day.
- Tender vegetables may not crop if they are sown directly outdoors – by the time the soil is warm enough, there may not be enough growing season left for them to mature.
- Tender crops tend to do better when they are started off in warm conditions.
- You can grow a quick 'catch' crop in the space that is waiting for transplants.

Disadvantages of raising transplants

- A light, frost-free, possibly warm, location is required.
- You need trays and compost.
- The seeds and seedlings need daily attention.
- Some vegetables, particularly root crops, do not transplant well.

TIP
Don't start your seeds off too early – the seedlings will still need somewhere warm and light to grow in once they have germinated.

Containers

Seeds can be sown into seed or module trays or small pots. You can recycle all sorts of containers, as long as you can make drainage holes in the bottom. Reuse pots and trays that you have bought plants in, ask your friends for any spare pots they might have, and even make your own!

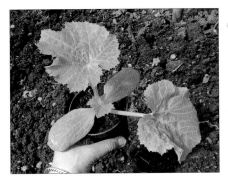

Multi-sowing

Beetroot and onions can be 'multi-sown' in larger modules. Sow three or four beetroot seeds or six onion seeds in each module, and do not thin them out. Plant each clump of seedlings out as normal, leaving all the plants to grow.

Plant pots

Max size 7–8cm diameter. Suitable for sowing large seeds such as pumpkins and squashes; also for raising seedlings for pricking out. Recycled alternatives include plastic yogurt and cream pots, and one-pint milk cartons.

Seed trays

These are shallow trays (2–3cm deep) made of plastic or wood. They come in standard sizes, usually quarter, half or full tray. A quarter tray will usually provide more than enough seedlings of one crop for pricking out (see page 23) and growing on.

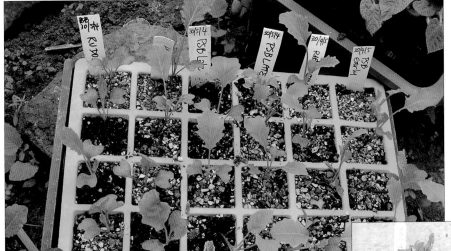

Module trays

Plants will get going much more quickly if you disturb the roots as little as possible when transferring them from their container to the soil. The easiest way to do this is to raise the plants either in biodegradable pots that can be planted into the soil, or in module trays. A module tray is simply a seed tray divided up into individual cells. Each plant grows in its own cell so that the roots don't get entangled with those of the other plants. Modules are particularly good for crops such as calabrese and beetroot that tend to go to seed if the roots are disturbed. The tray illustrated is growing purple sprouting broccoli.

Home-made biodegradable newspaper pots

These are good for raising plants such as beans, peas and sweetcorn which have long roots that do not like to be inhibited. Wrap a strip of newspaper several times around a plastic tube (approximately 3–5cm diameter). Twist the bottom to secure.

Rootrainers®

Peas, beans and sweetcorn, which have long roots, prefer these deeper modules.

21

Growing media

Use a good quality growing medium – either seed or multipurpose compost – for raising transplants. Plain old garden soil is not good enough, and garden compost on its own is too strong.

Sowing seed in modules

Preparing the compost

Scoop enough growing medium on to a flat surface. Break it up with your fingers if it is lumpy to give an even texture. Water the compost if it is dry and mix it up to distribute the water evenly. It should feel moist but you shouldn't be able to squeeze water out of it. If you have over-done it, add more dry compost. If the compost is cold to the touch, leave it to warm up, especially if sowing tender crops.

 Place the module tray on a flat surface with space around it. Over-fill the tray with compost, then tap the sides of the tray sharply to settle it. Pile on more compost if necessary and repeat. Using a straight edge, level off the compost. Using a presser tool, or your fingers, gently firm down the compost in each module. You should now be able to start sowing, but if the level is still too deep for tiny seeds add more compost and press down again gently. The aim is to cover the seeds with about their own depth of compost.

Sowing the seed

1. Sow two or three small seeds in each module. If the seeds are expensive or large, you may want to sow only one per module.

2. Cover the seed with compost and firm gently.

3. Label the tray with the date and the name of the vegetable.

4. Water well using a watering can with a fine rose attached.

Choosing a growing medium

- Multipurpose organic, peat-free compost.
- Organic, peat-free seed compost, for seedlings that are going to be pricked out.
- Coir can be used neat for sowing; add an organic fertiliser mix for growing transplants.
- Homemade, two-year-old leafmould can make a good medium for plant raising, but it does tend to grow a lot of weeds as well.

Tip

Don't sow the whole packet of seed unless you really need that many plants.

Raising transplants outdoors

Leeks, cabbages and many other brassicas are traditionally raised in a nursery bed outdoors, then planted out into their final growing site. Prepare an area of ground and sow seeds approximately 2.5cm apart, in rows 5cm apart. Transplant leeks when they are around 20cm tall, and brassicas when 15–20cm tall.

Once you have sown your seed, cover the module tray with a plastic propagator lid, a sheet of plastic or cling film, and put it in a suitable place, such as an airing cupboard or windowsill. Check regularly. As soon as the first seedlings are seen pushing through the compost, remove the cover if it would restrict the seedlings' growth. Once all the seedlings are through, keep the tray out of full sunlight for a few days to allow the seedlings to acclimatise.

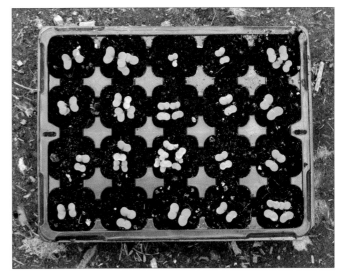

Sowing seed in pots or trays

Follow the same method as for modules, only this time scatter the seed thinly over the surface and sieve a fine layer of compost over the top. Prick out the seedlings as soon as they are large enough to handle.

Thin out seedlings to one per module (cell) as soon as they are large enough to handle.

Pricking out

If you have sown lots of seeds in a pot or tray, the seedlings need to be 'pricked out' to give them space to grow before being planted out. Do this as soon as the seedlings are large enough to handle. Loosen the soil with a widger, a teaspoon handle or a plant label, and gradually tease an individual seedling away from its neighbours, holding it by the leaves only. Make a tiny hole with a dibber in the container you are moving it into, and drop it in. Gently firm the compost, then water it. Keep the newly pricked-out seedlings out of strong light for a few days until they begin to grow.

Hardening off

Plants raised indoors are quite delicate and need to be toughened up before being planted out. This is known as hardening off. Place the pots and trays outdoors in a sheltered spot during the day, and for the first few days bring them back inside or cover them with a cloche overnight. Then leave them out at night too, as long as there is no danger of frost. After a week or so, plant them out into the garden, preferably on a dull, calm day.

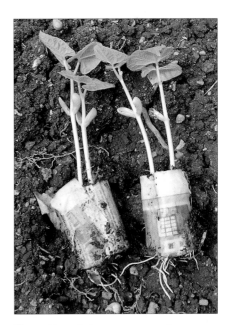

These French beans, grown in homemade newspaper pots, are ready for planting. There is no need to remove the pots first.

Planting transplants

Prepare the ground as for direct sowing (see page 18) and water it well if dry. Water the plants in their pots or trays a few hours before planting them out. Mark out the rows to be planted with string stretched between sticks. Check the spacing required (see pages 32–63). Use a trowel to make a hole slightly larger than the root ball of your transplant. Place the plant in the hole, fill up the hole with soil, and firm it gently. Plants should be planted no deeper than they were in their pot or tray, apart from tomatoes and brassicas, which can benefit from planting a little deeper. Water again to settle the roots, and again as necessary in dry weather, until the plants are growing strongly.

Planting leeks

Leeks are planted out when they are 20cm or so tall, but they can be left until they are larger. Make a 15cm deep hole using a dibber. Drop the leek plant in, then fill the hole with water. Do not fill the hole with soil. There is no need to trim the roots or the leaves before transplanting.

Good organic practice

To grow healthy vegetables, follow these basic organic gardening practices. You may sometimes need to protect your crop against specific pests or diseases, but a plant's first line of defence is sturdy, balanced growth. Give your vegetables the growing conditions they need and they will reward you well.

Start out healthy

Use good quality, organic seed. Buy seed potatoes, and onion, shallots and garlic grown specifically for planting, rather than using vegetables bought from the greengrocer. If you can, choose pest and disease resistant varieties.

Prepare the soil

Good soil preparation is the key to successful vegetable growing. Most vegetables growing in a well-prepared soil will not need any additional feeding. If you do need to add soil improvers and fertilisers, stick to the recommended amounts; too much nitrogen, for example, can make plants more susceptible to pests and diseases.

Watering

Vegetables need water to grow and produce a crop; they take water up from the soil through their roots. Too little water can make some plants more susceptible to disease, but too much can be just as bad. A well-prepared soil will hold on to good levels of moisture that plants can use, but not get waterlogged. You can also add organic mulches (see pages 26 and 27) to help keep the soil moist. Water young plants until their roots are established, but after that keep watering to a minimum.

- Collect and use rainwater as much as you can.
- Water the soil, not the foliage.
- When you do water, soak the ground really well. Check that the water has penetrated down into the soil.
- Use a watering can to show you how much water you have used. Aim for around nine litres per square metre at a time.
- Check pages 32 onwards for the most effective times to water.

Weeding

Weeds compete with plants for space, food and water. Remove weeds growing around seedlings and transplants regularly, either by hand or by hoeing. Once plants are growing strongly, mulches can be used to keep weeds under control (see pages 26 and 27).

Pests and disease

To stop pests and diseases from spreading:
- Clear away the affected crop before planting out more of the same, or related, plants.
- Remove diseased and dying leaves and plants and put them in the compost heap.
- Use crop rotation. This avoids the risk of pests and diseases in the soil that affect a specific crop from becoming a problem.
- Grow a susceptible variety mixed in with a less susceptible variety of the same crop.

TIP
Your vegetables are just a part of the whole garden environment, so use organic methods for the rest of the garden too.

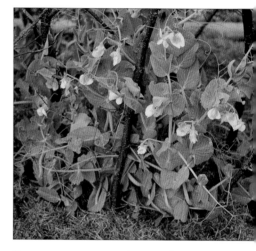

Peas are very prone to powdery mildew if the soil is dry. A mulch of grass mowings helps keep the soil moist.

TIP
Get into the habit of checking plants every few days. Many problems can literally be nipped in the bud.

Crop rotation

This involves moving a crop to a new site each year, returning to the original spot after three or four years.
- Divide your plot into three or four equal areas and allocate specific crops to each area. Keep crops in the same plant family together (pages 32–63 tell you which family each crop belongs to).
- Move them on one plot each year.

The Three Sisters

Corn, pumpkins or squashes, and climbing beans are a traditional Native American combination known as The Three Sisters. The corn supports the beans, the squashes suppress weeds, and the beans take up nitrogen from the air. They also make good use of space, and provide a well-balanced meal for the grower.

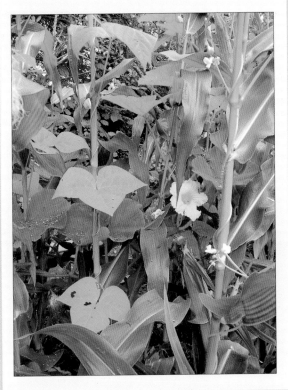

Good organic practice for the wider environment
- Make compost not bonfires.
- Recycle and reuse, or buy recycled products.

Companion planting

Some plants can benefit others if they are grown together. This is known as companion planting. It can work in various ways:

Attracting beneficial insects

Grow flowers that attract pest-eating insects alongside your vegetables. This should cut down on pests such as aphids and caterpillars.

Improving the environment

Sun-loving plants such as sweetcorn can provide vital shade for lettuces in the height of summer.

Trap cropping

This involves growing one type of plant to attract a pest away from another type. Some gardeners, for example, grow nasturtiums to attract blackfly and large cabbage white caterpillars away from crops. This can be risky, sometimes resulting in more pests rather than fewer, so requires careful monitoring.

Intercropping

Growing fast-maturing crops in between longer-term crops keeps the ground covered (so fewer weeds grow) and makes the most of limited space.

Confusing the enemy

Undersowing with non-related plants can confuse the pests, drawing them away from the crop. Clover, when used in this way, can be very effective in reducing pest levels, but it can also massively reduce the crop unless the timing is exactly right.

Masking the scent

Strong-smelling plants, such as onions, garlic and French marigolds, can mask the scent of a crop, effectively hiding it from some pests. For example, French marigolds may help against glasshouse whitefly.

Plant tonics

Plant tonics are the plant equivalent of vitamin pills, promoting healthy growth and resistance to pests and disease. Seaweed extract is the most well known, though more and more products are coming on the market which may be worth trying.

And finally ...

Don't panic! If your plants are not thriving, try to work out why. Plants can be affected by frost, drought, wind and soil deficiencies, as well as by pests and diseases. Once you have identified the cause of the problem, you can decide upon a course of action. Remember that you may not be able to grow everything – sometimes it's better to give up and grow something else.

Mulching and cover crops

A mulch is simply a layer of material that you spread over the soil. Mulches can be loose, such as leafmould or grass mowings, or sheet materials, such as cardboard or plastic. They can be homemade or recycled products, or purchased from garden suppliers. Compost and manures can also be used as a mulch, but only as a thin layer where feeding is required; other materials can be applied in a thicker layer.

Sheet mulches are usually covered with a loose mulch to keep them in place, or held down with heavy items. Use sheet mulches to clear an area that's become overgrown with weeds. Biodegradeable sheet mulches topped with a loose mulch will improve the soil's structure and nutrient levels, depending on the material used.

To control weeds on paths, lay a loose mulch of either wood chips or shredded bark, at least 7–8cm thick. You can use a thinner layer if you put down a sheet mulch first. Weed growth on soil is better dealt with using a mulch of autumn leaves, straw, cocoa shells, green waste compost or hops.

If you need to warm the soil, the best mulch to use is either a sheet of water-permeable plastic or other synthetic material, or black polythene.

Why mulch?

- Keep soil moist.
- Control weeds on soil.
- Control weeds on paths.
- Clear weeds from an overgrown area.
- Protect soil structure.
- Improve soil structure.
- Feed plants.
- Warm the soil.

Lay a wood-chip mulch on paths to control weeds.

LOOSE MULCHES		SHEET MULCHES
Leafmould	Green waste compost	Newspaper
Autumn leaves	Wood chips	Cardboard
Grass mowings	Shredded bark	Water-permeable plastic/synthetics
Straw	Compost	
Cocoa shells	Well-rotted animal manures	Black polythene
Hay	Mushroom compost	Biodegradable 'plastic'

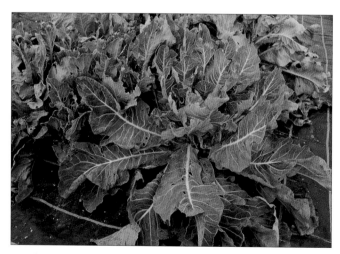

A woven, water-permeable plastic mulch.

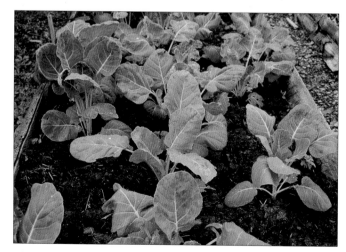

Use compost as a mulch where additional feeding is needed, such as on these Brussels sprouts.

Green manures

Green manures are plants grown to form a living mulch, covering the ground with weed-suppressing foliage while also improving soil fertility. They are sown where the ground would otherwise be left bare, in summer or winter, and then dug back into the soil before the plants begin to get tough.

A patch of a green manure will also provide a safe haven for ground beetles and other natural predators. Some types, such as buckwheat and phacelia, will attract bees and beneficial insects if left to flower.

Mulch runner beans with a straw mulch once they have started to grow strongly.

Green manure plants

- Buckwheat: sow in late spring to summer to grow for a few weeks. Frost tender.
- Phacelia: sow in spring to late summer to grow for a few weeks. An early autumn sowing will cover the ground over winter.
- Winter tares: sow mid- to late summer to grow over winter, and dig in in the spring. A good source of nitrogen.
- Grazing rye: sow late summer/early autumn to over-winter. Very hardy.

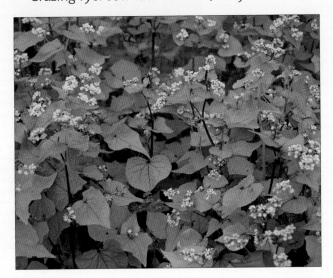

Buckwheat.

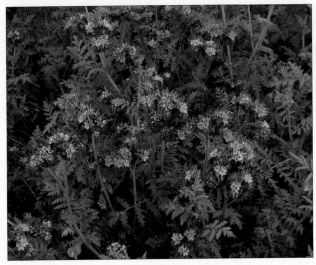

Phacelia.

Protecting your plants

Following the guidelines outlined in this book, from planting seeds to looking after the growing plants, is by far the best way to ensure a healthy crop. Sometimes, though, more direct action is needed to protect your vegetables, for example from damage by pests, diseases, frost and drought.

Crop covers

Covering your crops is a good way of protecting them from many pests and bad weather conditions. Lay a cover immediately after sowing or planting so that pests don't get trapped inside, then check underneath regularly for weeds or diseases. Remove the cover as soon as the plants are large enough to protect themselves, or the weather improves.

Fleece is a lightweight, synthetic material that can be laid directly over plants to protect them from frost and pests. Green plastic mesh, or even net curtains, supported with wire hoops, serve the same purpose.

Cloches provide protection from frost, cold weather and some pests. Cut the bottoms off see-through plastic bottles and flagons, and remove the tops to allow air to flow. Choose a bottle size that will not restrict the growth of the young plants, and remove the bottle when they start to get too large.

Plastic tunnels (tunnel cloche) are used to create a warm environment for early and late crops.

Pea wires laid over seedlings to protect them from birds.

Butterfly net over cabbages.

Organic pesticides

A few pesticides can be used in organic growing, usually as a last resort. Make sure you identify the pest correctly so you use the right product, and follow the instructions on the product label carefully. Use a good quality sprayer to get good coverage, and avoid spraying on windy days or where bees and other insects are working.

CAUTION!

Using home-made sprays, washing-up liquid or other household materials to treat pests and diseases is not recommended, and is in fact illegal. They could be a danger to wildlife and to your plants.

Distractants and scarers

Various methods can be used to scare off birds. Ring the changes, as birds do get used to them in time.

Slug and snail control

Slugs and snails are regarded as the number one pest by many vegetable growers. Here is a selection of methods you can use to protect your plants against them. It is best to use more than one method at a time as these pests are not easy to combat.

- Slug traps are easily made from empty plastic pots. Bury them in the soil so that the rim of the trap is about 2cm above the soil, and bait it with beer or milk.
- Cover lettuce leaves, or similar slug favourites, with a brick, tile or piece of wood. Check every day and remove any slugs.
- Clear plastic bottle cloches (see page 28) act as slug and snail barriers, but take care not to trap a slug inside!
- Copper discharges a mild electric charge that shocks slugs and snails on contact. It comes in the form of copper-coated fabric that you can cut to size to fit around your plants, and copper tape that you can put around containers and small raised beds.
- Plastic or copper 'collars' are useful for protecting individual plants, for example young courgettes or smaller plants such as lettuces.
- All manner of materials have been suggested as barriers to slugs, for example bran and comfrey leaves. Combined with another method, they are well worth a try. They are more likely to work under a cloche or other cover to keep the rain off.
- In nature, slugs in the soil are killed by a microscopic nematode worm. Biological control products boost the natural population of this worm by adding them in huge numbers. To protect plants for six weeks or so, all you need to do is to water the product on to the soil. These products don't work against snails.
- Ferric phosphate slug pellets: these look very similar to traditional slug pellets, but their active ingredient is harmless to wildlife.
- Simply picking slugs and snails off by hand can be very effective, particularly in protecting young plants. This is best done at night.

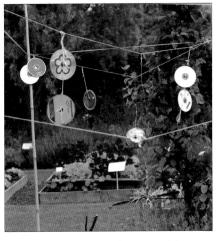

Brightly coloured, reflective old CDs and DVDs strung across your vegetable plot make excellent bird deterrents.

TIP
Snails are generally not as easy to control as slugs. Try to avoid growing vegetables close to areas where snails may congregate, such as an ivy-covered wall or a heap of stones.

TIP
Start clearing slugs from a bed a week or two before planting out vulnerable transplants. Use traps, or biological control.

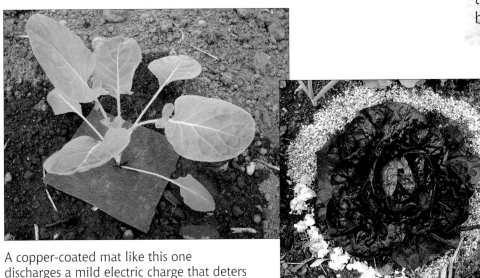

A copper-coated mat like this one discharges a mild electric charge that deters slugs and snails on contact.

A thick layer of crushed eggshells may help to keep slugs at bay.

Working with nature

Natural creatures, from microbes to birds, play a vital part in an organic garden. Although some are inevitably pests and diseases, they are all part of the natural web of life where creatures eat other creatures, and in turn are themselves eaten. In this way a balance is kept.

Make your garden a place that welcomes wildlife, and your plants will thrive. You'll be doing your bit for nature conservation too, and you can enjoy the extra dimension that birds, butterflies and bees bring to a garden. Don't worry – this doesn't mean that your garden has to look like a nature reserve. Here are some ideas for making a garden wildlife friendly, without spoiling its looks.

TIP
The environment below ground is equally full of creatures. Caring for your soil organically will help to keep them in balance. Adding compost and other organic materials to the soil is a good way to boost health and the variety of creatures in the soil, and to reduce the damage that soil pests and diseases cause.

Predators and pests

Frogs feed on slugs, snails and woodlice.

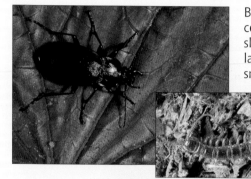

Black beetles and centipedes eat slugs, root fly larvae and other small pests.

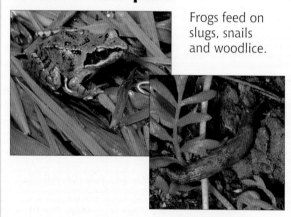

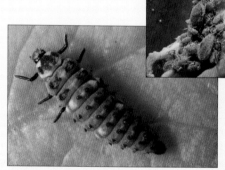

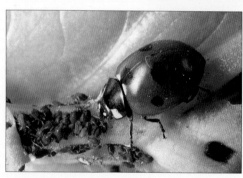

Ladybird larvae eat greenfly, blackfly and other aphids.

Ladybirds eat greenfly, blackfly and other aphids, scale insects, whitefly and mildew. Leave aphids alone where they are not causing a problem (such as on an established shrub or tree). Ladybirds and other creatures that eat aphids need a supply of the pest so they can feed and multiply, and then move on to the rest of your garden.

Aphids may have wings at certain stages of their life.

Caterpillars are eaten by wasps and bluetits.

Attractant flowers

Many natural predators also need nectar and pollen in their diet. You can grow suitable flowers around your garden, or even mixed in amongst the vegetables, that these tiny creatures can feed on. Avoid double-flowered varieties as these are more difficult for insects to feed on.

Flowers that attract wildlife

Pot marigold	Fennel	Chervil
Gazania	Coriander	Cornflower
Poached-egg plant	Carrot	Corn marigold
Phacelia	Parsnip	Corn chamomile
Goldenrod	Candytuft	Michaelmas daisy
Fern-leaf yarrow	Californian poppy	

For carrots and parsnips, leave a root in the ground to flower the following year.

Goldenrod (top) and gazania (bottom) are good attractants for hoverfly.

Ground cover

Creatures need hideaways and safe routes around the garden. Small creatures such as centipedes and beetles appreciate mulches. Ground cover plants also make good safe routes.

Cleaning up every corner of the garden, cutting down seed heads, and vacuuming up every last leaf, is not the best way to encourage wildlife in the garden as it removes vital habitats.

Shrubs and hedges

Nest boxes and birdfeeders are great for making birds welcome, but they will also enjoy natural habitats – bushy shrubs, a hedge or a climber on the wall will all provide safe shelter. Berried shrubs are a good natural source of food for birds.

Water supply

A small pond is great for wildlife if you have room for it. Even a shallow dish of water will be welcomed.

Safe havens

- Heap up a pile of logs or stones in a corner.
- Leave herbaceous stems on plants over winter; cut them down in the spring.
- Let autumn leaves collect under a hedge or in a spare out-of-the-way corner.
- Don't cut the whole lawn short every time. Leave a patch to grow longer.

Studies have shown that fennel, blooming from July to September, can attract around 500 different species of insect; of these 195 were found to be predatory and 105 parasitic.

A garden pond is an excellent way of attracting beneficial wildlife to your garden.

French beans

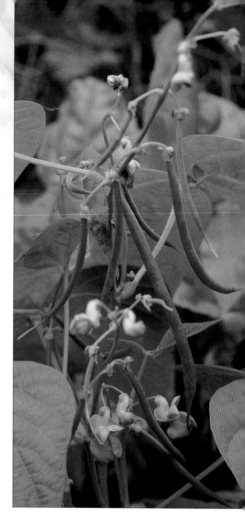

French beans are a tender crop. They grow well once the weather, and the soil, have warmed up, and they can be more reliable croppers than runner beans. Their season can be extended by growing them in a greenhouse or under a cloche.

There are both dwarf and climbing varieties. Dwarf varieties make bushy plants, 30 to 60cm high, and do well in containers. Climbing varieties, when grown up a wigwam of canes, make splendid ornamental features – particularly those with coloured stems or pods.

French beans are usually eaten as fresh young pods. If left longer on the plant, the seeds will swell; these can be podded out and eaten fresh (cooked), or left to dry to produce a crop of dried beans.

Sowing and planting

French beans must be sown at a temperature of at least 13°C to germinate and grow well. Raise them in semi-deep modules or pots, then transplant them after the last frost, or under cover. Alternatively, sow the seeds direct outdoors once the soil has warmed up, in May and June; May to July for dwarf varieties. You can make several outdoor sowings in a season. Extend the season by growing dwarf varieties in a cold greenhouse or polytunnel, or under cloches to protect them from frost.

Beans for drying should be given as early a start as possible. They need a long growing season and a dry autumn to do well, so they are best suited to the drier parts of the country.

French beans in flower.

Which variety?

- Dwarf: 30 to 60cm high
- Climbing: 180cm high
- Pod colour: green, yellow, purple, green/purple, red/yellow
- Pod shape: flat, pencil, wide
- Beans for drying: most varieties will produce dry seed, but some are more suited for this than others. Dried beans may be white, black, brown, red or speckled/bicoloured

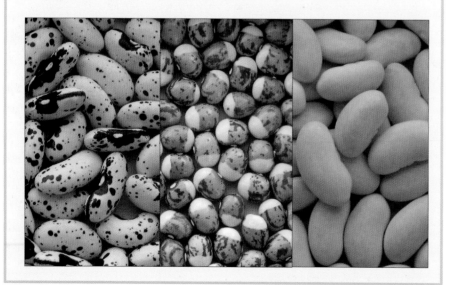

French bean seeds sown in home-made pots made from newspaper.

SPACING

Traditional plot

Dwarf: 5–7 x 45–60cm, depending on variety
Climbing: Grow up canes in double rows, or a wigwam; 10–12cm between canes, two plants per cane

Beds

Dwarf: 15–20cm each way
Climbing: as for traditional plot

Where will they grow?

French beans need full sun and a warm soil to thrive. Grow them where the soil has been improved for a previous crop, or add a low-fertility soil improver.

Growing in containers

Dwarf varieties grow well in containers. Try four plants in a trough roughly 15cm deep and 60cm long. This is a good way of growing an early and a late crop, if you can protect them against frost.

Crop care

- Provide a wigwam or double row of canes for climbing plants to grow up, allowing two plants per cane. Other more decorative structures can be constructed using hazel or other poles.
- Apart from young transplants, there should be no need to water.
- Keep weed-free.

Harvesting, eating and storing

Harvest regularly once the pods are large enough to eat. French beans can be frozen.

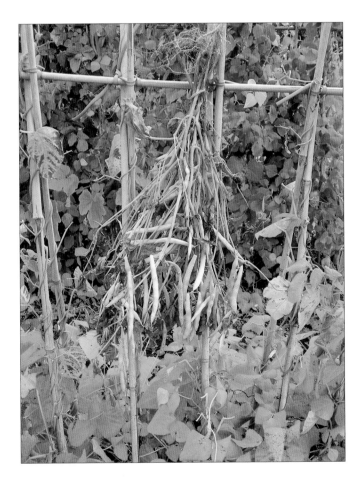

Bean trench

In the autumn, dig a trench a spade deep and about 60cm wide. Gradually fill this with vegetable waste, covering each layer with a little soil. In March, replace the remaining soil in the trench and leave it to settle before planting out beans in the normal way.

Look out for:

- Slugs: particularly when plants are small, and in poor weather.
- Red spider mites: may appear in very hot, dry weather.

French beans growing up a home-made structure.

Don't pick fresh pods if you are growing beans for drying as this will delay their development. Leave the pods on the plant until they are brown and crisp, then harvest and shell out the beans. If the pods have not dried out by the time the weather has turned wet in the autumn, the beans can be shelled out, then stored in the freezer for future use in soups and stews. These are known as 'demi-sec'.

Family: Leguminosae (Fabaceae)

Runner beans

Runner beans are a must for home vegetable growers. Freshly picked, the long, green, rough pods are much tastier than shop-bought ones. Most runner beans are vigorous climbers, twining their way up to 3m or more. Runner beans are frost tender, and need warm conditions to get started and plenty of water when the pods are forming.

Sowing and planting

For an early start, sow seeds in deep modules or pots a couple of weeks before the last frost. Plant out after the last frost, when the soil is warm. Runner beans can also be sown direct in May and June.

Crop care

- Protect young plants from slugs and snails.
- Dwarf varieties may need extra support to keep plants off the ground.
- Mulch plants with a low-nutrient soil improver once they are growing well, or dig a bean trench (see page 33).
- Water well in dry weather once the flowers start to form.

> **SPACING**
>
> Double row of canes: 15 x 60cm

> **Which variety?**
> - Dwarf: 45cm high
> - Climbing: 2.5–3m high
> - Flower colour: white, red and white, salmon pink
> - Seed colour: white, purple, black

Harvesting, eating and storing

Start picking the long, slim pods when they are around 15cm long. Regular picking (every couple of days in good weather) will give you a longer cropping season. Eat the whole bean pods sliced, lightly steamed or boiled. The pods will keep for a few days in the fridge, or can be frozen.

> **Where will they grow?**
>
> Grow runner beans in a sunny spot, which is not too windy. They need a warm soil that holds moisture well, particularly in mid-summer when the beans are forming. Grow climbing varieties where they will not shade other plants.
>
> *Growing in containers*
>
> Dwarf varieties, which tend to flop over, can also be grown in a large container.

> **Look out for:**
> - Slugs and snails early in the season.
> - Blackfly: squash by hand or use a spray.
> - Flowers failing to set pods: this can be due to dry soil, or poor pollination if the weather prevents bee activity.
> - Flowers destroyed by birds.

Make a striking feature of your runner beans by growing them up a wigwam or double row of canes or other bean poles. Use 2.5m long poles, and make it sturdy enough to support the fully grown plants and crop.

Family: Leguminosae (Fabaceae)

Broad beans

Broad beans are a hardy, cool season vegetable, one of the earliest to crop. They are easy to grow, needing little care and attention. They produce large, plump pods containing green, pale green or red seeds. The plants grow to around 75cm tall, though there are also dwarf varieties, and bees love the deliciously sweet-scented flowers.

Which variety?
- Winter or spring sowing
- Dwarf or tall
- Crimson flowered (Heritage variety)
- Green, pale green or red beans
- Medium or long pods

Sowing and planting
Station sow suitable varieties in autumn (except on heavy soils that tend to be wet over winter) or in spring as soon as soil conditions are suitable. Broad beans have a relatively short harvest period, so it is best to make several smaller sowings, at three-week intervals up to the end of April, rather than all at the same time. You can also raise seedlings in deep modules or paper pots, sowing from late winter; harden off and plant out as soon as the young shoots appear.

Crop care
- Keep weeds down when plants are small.
- Support tall plants on windy sites with a network of strings.
- Mulch plants on light soils.
- Water on dry soils in dry weather once the pods start to form.

Look out for:
- Mice: these may eat the seeds from autumn and early spring sowings.
- Blackfly: plants sown in autumn and early spring are less susceptible to blackfly than those sown later. Pinch out infested plant tops; remove badly infested plants to the compost heap; spray well.
- Chocolate spot: a disease which causes dark brown spots on leaves, stems and pods of broad beans only. Remove badly infected plants to the compost heap; use a crop rotation.
- Pea and bean weevil: this small, browny-grey weevil eats notches out of peas and broad bean leaves. Plants are usually able to tolerate the damage.

Harvesting, eating and storing
Autumn sowings should be ready to pick in late May/early June; spring sowings a few weeks later. Broad beans are best harvested when the beans are young. You may have to open a few pods to check, as the size of the beans is not always obvious from the outside. Small pods can be eaten whole, but it is the podded beans that are usually eaten. Broad beans freeze well.

SPACING

Traditional plot
Double rows, 15 x 20cm; allow 60cm between double rows

Beds
20–30cm each way

Where will they grow?
Broad beans will grow on most soils, but avoid autumn sowing on very wet soils. They grow well on soil fed for a previous crop; add low-fertility soil improver to light soils to increase water-holding.

Growing in containers
Broad beans are not particularly suited to growing in containers.

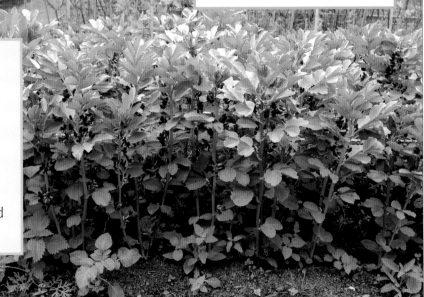

Crimson-flowered broad beans, Heritage variety.

Family: Leguminosae (Fabaceae)

Peas

Peas are one of the UK's favourite vegetables. They are a hardy, cool weather crop, well suited to the cooler climate. Traditionally eaten as small green peas, some varieties can be eaten pod and all, and you can even eat the tendrils. By growing a range of varieties you can harvest peas from May right through to October. The plants need the support of twigs or pea netting for their tendrils to cling to as they climb.

Sowing and planting

Sow round-seeded varieties in October and November, directly into the soil. All other varieties should be sown from March to July, either directly where they are to grow, or raised in deep modules first.

SPACING

Sow shelling peas in broad drills 23cm wide, setting seeds 5cm apart over the bottom of the drill. The space between each drill should be approximately the same as the final height of the plants.

Short or semi-leafless varieties that don't need support can be grown in a block, allowing 7cm between seeds.

To beat the mice, which love pea seeds, sow a row in a length of plastic guttering. Slide the whole row into place outdoors when the seedlings emerge.

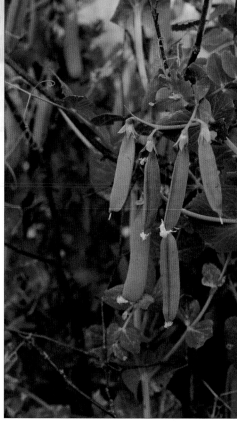

Peas are at their tastiest when eaten straight from the pod.

Which variety?

- Shelling peas: remove the seeds from the pod to eat.
- Round-seeded: extra hardy for autumn sowing but less sweet than most.
- Wrinkled-seeded: suitable for spring sowing, though pod size and crop tend to be greater if sown later. Height 60–76cm.
- Purple podded: violet flowers and pods. Height 1.8m.
- Mangetout and sugarsnap peas. Sugarsnap peas make a good early crop in a greenhouse or polytunnel, sown in January or early February.
- Leafless: more tendrils than leaves; when grown in a block, they support themselves. The tendrils are edible.
- Tall peas: grow up to 2m. Heritage varieties and some sugarsnaps.

Mangetout (far right) and self-supporting peas (right).

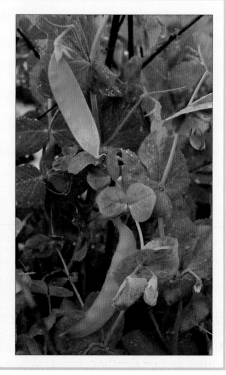

Crop care

- Provide suitable height supports from the start, for example pea sticks or pea netting. Peas cling with tendrils whereas beans climb by twisting around a pole.
- In dry weather, watering after the first flowers have opened will increase yields and reduce the threat of powdery mildew; watering before flowering will not help the crop very much.
- Mulch dry soils with a low-nutrient soil improver.

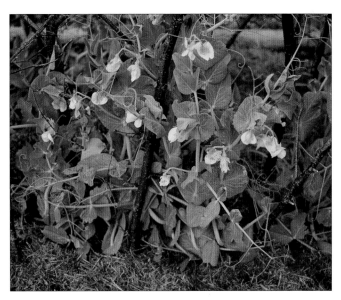

A mulch has been laid on top of the soil around these peas to help it retain moisture.

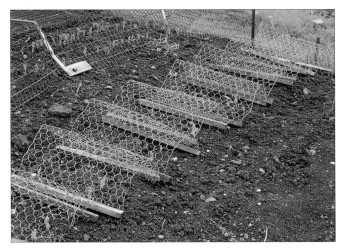

Birds love young pea seedlings; protect them with mini wire cloches.

Tip
The space between rows of peas can be used for a quick crop of radishes or lettuces.

Where will they grow?
Peas need a soil that holds water, but isn't poorly drained. They grow well on soil that has been improved for a previous crop. On light soils, add leafmould or other low-fertility, water-retaining soil improver before sowing. Peas will tolerate light shade in the summer, but not a dry soil.

Harvesting, eating and storing
Pick shelling peas as soon as you can feel them through the pod; younger peas have a better flavour. The pods can be made into soup if you sieve out the tough pod membrane. Pick mangetout pods before the peas start to swell; sugarsnaps when the pods are plump. Tendrils can be harvested at any time. All pea varieties can be eaten raw or lightly cooked, and they freeze well.

Look out for:
- Mice: these love pea seeds, particularly early in the season when there is little else for them to eat.
- Slugs.
- Pigeons.
- Pea and bean weevil: this small, browny-grey weevil eats notches out of peas and broad bean leaves. Plants are usually able to tolerate the damage.
- Powdery mildew: a white, powdery coating on leaves and pods. Common in dry, hot weather. Keep plants watered and mulched, and avoid sowings that will crop in the height of summer.
- Pea moth: the small caterpillars feed on peas inside the pods. Early and late sowings are less susceptible than those in mid-summer. If the problem is severe, cover the peas with a fine mesh before the flowers open, particularly if they are flowering in July when the moth is most active.

Pea moth caterpillar, and the damage it causes.

Beetroot, chard, leaf beet and spinach

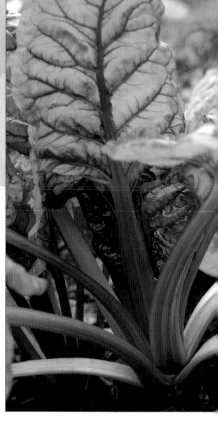

Beetroot, chard (sometimes called Swiss chard or silver beet) and leaf beet (also known as spinach beet or perpetual spinach) are all basically varieties of the same plant. Beetroot has been bred for its tasty root, leaf beet and chard for their leaves. All are hardy, easy-to-grow crops that thrive in a cool climate.

Spinach is in the same family but is not always as easy to grow. Given the right conditions it can be picked just a few weeks after sowing, but unlike chard and leaf beet, each sowing does not last for long – it needs regular picking. Different varieties can be sown all year round, but it grows best in the cool of spring and autumn.

Chards have a wide leaf midrib, which can be eaten separately, and comes in a variety of colours – from white, red or yellow to luminous pink and orange. The variety shown above is known as Red, Ruby or Rhubarb chard.

Which variety?

Beetroot

- Resistant to bolting
- Small round, large round, and long cylindrical roots
- Decorative red foliage
- Orange, white, or red and white flesh
- Monogerm seed – beetroot 'seed' is in fact a cluster of seeds, so each one produces several seedlings. Monogerm seed produces only one seedling per seed.

Chard

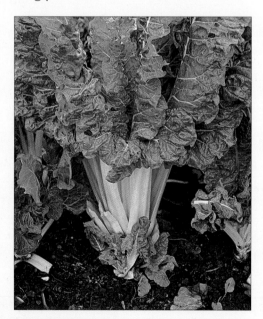

- White, yellow, red or mixed-colour leaf midrib. Foliage light to dark green; flavour very similar.

Spinach

- Spring and autumn sowing; summer sowing
- Resistance to powdery mildew

White-stemmed chard.

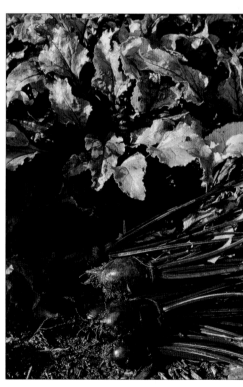

These juicy beetroots can be eaten raw or cooked. The stems and leaves are also edible.

TIP
Small and early beetroot varieties are much quicker to crop than the larger, main-crop varieties.

Where will they grow?

Beetroot, leaf beet and chard need a good moisture-retaining soil. Add a low- to medium-fertility soil improver. Plants will tolerate some shade, as long as the soil is moist.

Growing in containers

Baby beet varieties that produce small, globe-shaped roots are best for container growing. Spinach beet and chard, which can crop over several months, need a reasonable sized pot – 20–30cm at least – or can be mixed in with other crops in a larger pot. Spinach is best grown in a wide box, around 15cm deep, as a baby leaf crop. Remember to keep it well watered.

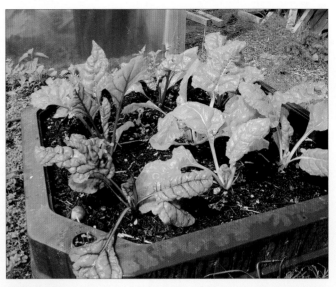

Rainbow chard growing in a raised bed in light shade.

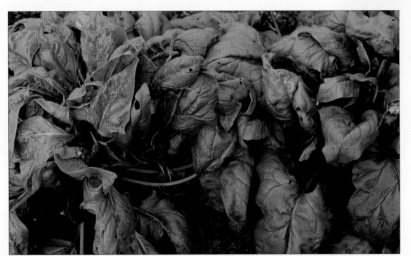

Spinach is a quick-growing crop that will rapidly run to seed if the conditions are not right. It needs a good moisture-retaining soil that does not dry out. In summer, spinach is best grown in light shade.

TIP
You can extend the season of all these crops by growing them in an unheated greenhouse or polytunnel, or under cloches.

Sowing and planting

Sow varieties of beetroot that are resistant to bolting outdoors from March. Sow other varieties when the soil is warm, usually around April. Sowing can continue until June or July. Quick-growing varieties are best for the later sowings. Beetroot can also be raised in module trays for transplanting without disturbing the roots. Early and small round beets can be multi-sown (see page 21), with three seeds per module. Thin, if necessary, to five seedlings per module, then plant out when hardened off (see picture on page 40).

Leaf beet and chard should be sown direct in March/April for a summer crop, then again in July/August to crop over winter and the following spring. Alternatively, raise plants in modules for transplanting.

Sow spinach directly into the soil from early spring through to late autumn. Sow another batch once the previous sowing has just appeared. As spinach prefers light shade in hot weather, it can be grown between taller crops as long as the soil stays moist.

SPACING

Beetroot:
Traditional plot
Early and quick varieties:
10 x 23cm
Larger rooted varieties:
10 x 30cm
Mini beets: 2.5 x 15cm
Multi-sown: 22 x 22cm

Beds
12.5–15cm each way

Leaf beet and chard:
Traditional plot
23 x 38cm

Beds
23cm each way

Spinach:
Traditional plot
15 x 30cm

Beds
15cm each way

For growing as a baby leaf seedling crop, see page 51.

Crop care

- Keep weed-free. Thin as necessary to required spacing. Eat the thinnings.
- Water spinach in dry weather.

Harvesting, eating and storing

Beetroot

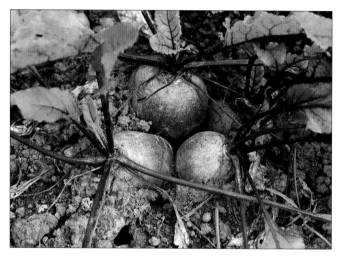

Multi-sown beetroot. Harvest beetroot when young for a sweet and tender crop. Larger roots can be lifted in the autumn and stored over winter. Roots may be left in the ground for a few months if slugs are not a major problem, but will not stand severe frosts.

Leaf beet and chard

Pick individual leaves as soon as they are large enough, or cut whole plants down to 2–3cm and leave them to regrow. Plants can be picked over a period of several months.

Spinach

Pick regularly as soon as the leaves are big enough.

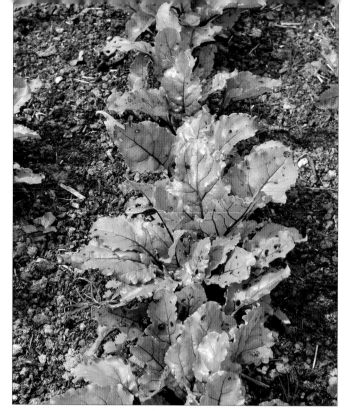

Grow beetroot in rows, keep weed-free, and thin as necessary.

Harvesting semi-mature plants

Plants can be harvested when they are a reasonable size, but well before they are mature. Pick individual leaves or cut off whole plants leaving a stump of 2.5cm or so. This will regrow another crop of leaves. This is a good way of harvesting your vegetables in autumn/early winter. You don't have to wait until the plants are mature to get something to eat, and the regrowth is usually more tolerant of cold weather than the mature plant.

This method is suitable for **endive, sugarloaf chicory, oriental greens, Chinese cabbage, pak choi, chard** and **spinach beet.**

Look out for:

- Bolting: this is when a plant produces a flower stem prematurely. Early sowings of beetroot are prone to this (unless you use bolt-resistant varieties). Spinach will tend to bolt quickly in hot, dry weather.
- Beet leaf miner: creates brown blotches on beetroot, chard and spinach beet leaves. Pick leaves regularly, particularly the older ones, to disrupt the life cycle.

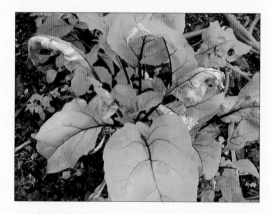

Leaf miner damage on beetroot leaves.

- Powdery mildew: this disease can affect spinach, chard and leaf beet. It creates a grey, powdery coating on the leaves, usually in hot, dry weather. To avoid the problem, improve soil water-holding capacity, grow resistant varieties of spinach, and water in very dry weather.

Family: Brassicaceae (Cruciferae)

Brassicas

The brassicas (cabbage family) include many vegetable crops that are readily available in the shops. They are usually quite easy to grow, as they thrive in the British climate, if precautions are taken against a range of pests and diseases. Some will tolerate light shade. Brassicas are high in vitamins and minerals, and are rich in antioxidants and other compounds that can protect against disease.

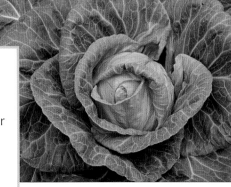

Romanesco broccoli (also called cauliflower) produces unusual heads of lime green, pinnacle-shaped florets.

Cabbage

If you grow a range of varieties, you can have fresh cabbage all year round. Some are very quick growing; others will stand happily in the garden for many months until you want to eat them, even over winter.

Which variety?
- Red, green or 'white'
- Produce a tight head or leafy greens
- Plain or 'blistered' leaves

Sowing, planting and harvesting

Raise seedlings in modules or in a seedbed. Transplant them to their final growing position when they are 7–8cm tall. Where space is limited, go for quick-growing, early summer cabbages or small-headed varieties that stand well.

Type of cabbage	Sowing time	Spacing	Harvest period
Summer	February/March	35–45cm	June/July
Summer (under cover)	January/February	35–45cm	May/June
Autumn	March/April	50cm	September–December
Winter	April/May	50–60cm	December–February
Savoy	May/June	50–60cm	December–February
Spring	August	30 x 30cm	April/May

Spring cabbage – sown in late summer, eaten in spring.

Calabrese

By growing a selection of varieties, you can crop calabrese from June to either September or the first hard frost, whichever is sooner. The season can be extended by growing plants in a greenhouse or polytunnel at the beginning and end of the season.

Sowing, planting and harvesting

Sow seed from March in modules, or directly into the soil in April and May. Do not transplant bare-rooted plants. Cut the main head while the buds are still tight; secondary, smaller heads will be produced as side shoots.

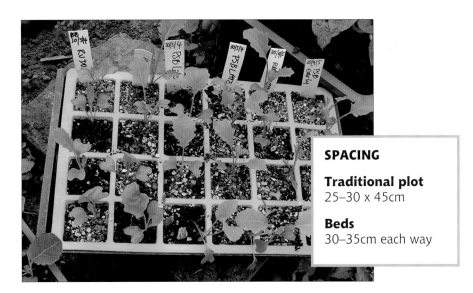

Young brassica seedlings growing in modules.

SPACING

Traditional plot
25–30 x 45cm

Beds
30–35cm each way

Kale

Kale is a hardy, nutritious vegetable that is tasty and easy to grow. Varieties such as Cavalo Nero (Black Tuscany) and Ragged Jack can be sown throughout the year and picked when only a few weeks old. Other kales are best grown into mature plants over winter, as they need a cold snap to make them edible. Some varieties are very ornamental; a combination of red and green curly kale, for example, makes a stunning winter display. Kale will tolerate some shade.

Sowing, planting and harvesting

For a winter crop, raise transplants or sow seed direct in spring and early summer, 30–75cm apart depending on variety; rape kales can be sown direct as late as August. For picking young, sow from spring to autumn. Pick young leaves as soon as they are large enough, or when the plant is full size. Kale can be picked over many weeks.

Sow cut-and-come-again kale in early spring, 15cm apart, in rows or in wide drills. Harvest as large seedlings; alternatively thin to 7cm, cut when 15cm tall and leave to regrow – or just keep picking individual leaves. Protect with a cloche until the weather warms up.

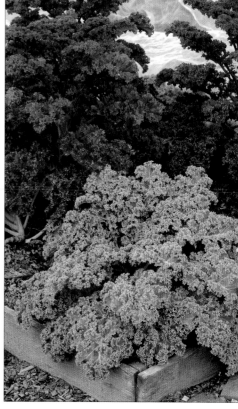

Purple and green curly kale.

Kohl rabi

The spherical swollen stem, the 'bulb', of kohl rabi (which can be purple or 'white' skinned) gives this vegetable a rather bizarre appearance. It is quick to grow (cropping within eight weeks) and can be sown and harvested nearly all year round.

Sowing, planting and harvesting

Sow every few weeks for a regular supply, as most varieties of kohl rabi do not stand for long once ready to harvest. Sow in modules from late February to August, planting out when no more than 5cm tall. Sow in September to grow over winter under cover. Kohl rabi can also be sown directly into the soil from March to August. Do not transplant bare-rooted plants. This vegetable can tolerate light shade. Harvest when the 'bulbs' are about tennis-ball size and eat them raw or lightly cooked.

SPACING

Traditional plot
18 x 30cm

Beds
25cm each way

Purple sprouting broccoli

Sprouting broccoli produces large plants that stay in the ground for around nine months or more, so it may not be suitable for all gardens. But this delicious vegetable produces its purple-budded shoots in late winter/early spring when fresh vegetables are scarce, so it is well worth growing. Varieties are now available that will also crop in late autumn.

Kohl rabi, purple variety.

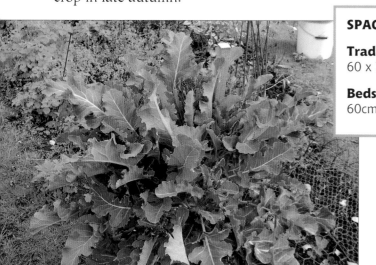

SPACING

Traditional plot
60 x 75cm

Beds
60cm each way

Purple sprouting broccoli, supported by a sturdy stake.

Which variety?

Modern varieties of broccoli, such as Claret, produce larger heads than the old-fashioned 'purple sprouting', but the latter will crop over a longer period.

Sowing, planting and harvesting

Raise sprouting broccoli in modules or a seedbed. Sow in April or May and plant out when 15–20cm tall. Pick shoots when the purple buds show.

Summer radishes and early turnips

These are quick-growing, tasty roots that need cool, moist growing conditions.

Sowing, planting and harvesting

Sow seeds direct; these plants are not suited to transplanting. Protect with cloches for an early crop. Sow early turnips from March to June, and summer radishes from late February to September, avoiding hot, dry months. Plant in soil that has been improved for a previous crop. A low-nutrient soil improver can be added to light soils so they are better able to hold water.

Which variety?

Summer radishes are small, pink/red or bicoloured, round or elongated. Early turnips have white flesh.

SPACING

Turnips
10 x 23cm; 15cm

Radishes
2.5 x 15cm; 10cm

Intercropping

Growing cabbages between green plants of a different family, such as French beans or clover, can reduce damage to the cabbages by root fly, aphids and caterpillars. The chance of a pest landing on a cabbage plant is lower when the cabbages are mixed with other types of plant.

Where will brassicas grow?

Open sites are fine; brassicas will tolerate windy conditions. Kale and kohl rabi will tolerate some shade. All brassicas grow well in moisture-holding soils, which allow deep rooting. Improve the soil with garden compost or other medium-fertility soil improver, or use a nitrogen-rich fertiliser and leafmould for moisture-holding. Leafy brassicas grow well after winter tares green manure (see page 11). Radishes and turnips do not need a rich soil, but they do need a soil that does not dry out. Improve lighter soils with a low-nutrient soil improver.

Growing in containers

Early turnips, kohl rabi and radishes are all suitable for growing in containers; kale, cabbage, calabrese and broccoli are not.

Crop care

- Cover seedlings and young transplants with fleece or fine mesh to protect them from pests (see page 43).
- Water transplants regularly until they are growing well. After that, only water them in very dry conditions. Don't allow radishes and turnips to dry out.
- Tie broccoli plants to a sturdy stake as they grow.

Look out for:

- Flea beetle: can devastate young brassica seedlings; young radishes and turnips are particularly susceptible in hot, dry weather.
- Cabbage root fly: attacks roots. Transplant through 'cabbage mats' or grow under fleece.
- Whitefly: tend to appear later in the year on broccoli, kale and calabrese, particularly in dry conditions. Remove lower leaves; a strong jet of water can dislodge the pests.
- Caterpillars: check plants when you see the cabbage white butterflies fluttering around. Squash eggs and caterpillars. Wasps may carry off all the caterpillars to feed their young.
- Mealy cabbage aphids: as these aphids feed they distort the leaf. This can stunt growth of seedlings. Squash or spray pests on young plants, and also on older plants if no predators and parasites can be seen (see page 30).
- Clubroot: disease that deforms roots. A bad attack will kill plants. It can last for twenty years or more in the soil and affects nearly all members of the cabbage family. To avoid infection, raise your own plants or buy them in from a reputable source, and use a four-year crop rotation, or longer.

Family: Brassicaceae (Cruciferae)

Oriental brassicas

Oriental brassicas are a relatively new introduction to the UK and are particularly suited to late summer/autumn cropping, filling a useful gap in the gardening year. They are grown for their leaves, leafy stems, midribs and flowering shoots, and their rapid growth means you can produce a crop within a few weeks. They are an excellent choice for a quick 'catch' crop between other vegetables.

Green in the snow – a very hot mustard green.

Sowing and planting

Oriental brassicas, except the root crops, can be sown direct or transplanted from modules in late summer or autumn. Many types will survive the winter with some protection, and others are hardy enough to survive outdoors. A number of varieties can be grown as baby leaf crops (see page 51).

Crop care

- Water plants in dry weather, particularly Chinese cabbage and pak choi.
- Protect from flea beetle when young with a fine mesh cover.

Look out for:
- Clubroot (see page 43)
- Flea beetle (see page 43)
- Slugs (see page 29)

Where will they grow?

Oriental brassicas need a fertile, moisture-retaining soil to maintain their vigorous growth. Treat soil with a medium-fertility soil improver before sowing or planting, or grow where the soil has been improved for a previous crop.

Growing in containers

All those listed on these two pages, apart from mooli radishes, are suitable for growing in containers.

Harvesting, eating and storing

Harvest as seedlings, young plants or as semi-mature plants. Alternatively, cut them when mature, leaving a stem of around 2.5cm to allow regrowth for another crop. Pick leaves from loose-headed varieties as required. A seedling crop can be ready within a few weeks and can be cut two or three times before it stops regrowing.

All oriental brassicas can be eaten raw or lightly cooked. They have a slightly peppery flavour, varying from mild to hot depending on the crop. The stems are usually crisp and juicy. They are best eaten fresh, though Chinese cabbage will keep for several weeks in the fridge.

Chinese cabbage

Chunky heads and crinkly leaves with crisp, white midribs. Usually grown to produce mature heads, which are ready to harvest in six to seven weeks. Sow direct or transplant from modules from late June to August; varieties that are resistant to bolting can be sown from March. For mature heads, plants should be spaced 30 x 30cm.

Which variety?
- Barrel-shaped heads/slimmer, cylindrical, taller heads
- Loose headed
- Resistant to bolting

Pak choi

Heads of loosely packed green leaves with crisp, wide, white or green midribs which tend to be broader at the base. Midribs are succulent and mild flavoured;

Which variety?
- White or green midribs
- Tall (up to 45cm) or dwarf (up to 10cm)

excellent eaten raw but can also be cooked. Sow direct or transplant from modules from late spring to August. Thin to or transplant at 20–30cm intervals for mature plants, 15cm for semi-mature. Choose a variety resistant to bolting if sowing before mid-summer. Pak choi crops well late in the year if planted under protection in late summer/early autumn.

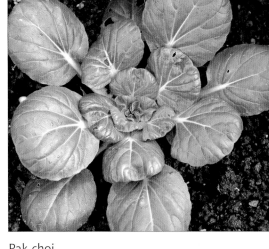

Pak choi.

Komatsuna (mustard spinach)

A frost-hardy plant with crisp, dark green stems and long leaves. Pick individual leaves and eat them cooked or raw. Vigorous and quick growing, komatsuna can be harvested within a month of sowing. Sow seed direct or transplant from modules from spring to autumn. Space 30–45cm each way for mature plants, 20cm for semi-mature.

Mibuna greens

A squat, bushy plant with a spray of long, narrow leaves. Eaten raw or cooked, it has a mild mustardy flavour. Grown as a baby leaf crop, it can be ready in twenty-five days. Mature plants can be harvested within two months. Seeds are best sown in spring and autumn; this vegetable does not do well in hot weather. Space at 20cm intervals for mature plants; 15cm for semi-mature.

Komatsuna.

Mizuna greens

A decorative plant with long, finely divided leaves produced in a spray from the ground. It has a slightly stronger flavour than mibuna and can be eaten raw or lightly cooked. Pick individual leaves, or cut whole plants three or four weeks after sowing. Flowering stems can also be eaten if the plants bolt. Seeds are best sown in spring and late summer/autumn. Space out at 25cm intervals for mature plants, 15cm for semi-mature. Early and late sowings may need some protection. Plants will survive the winter well under cloches.

Green in the snow

A very hardy, very hot mustard green. Sow seed in late summer/autumn, and pick individual leaves or cut whole plants. Space out at 25cm intervals for mature plants, 15cm for semi-mature.

Mizuna.

Mooli or daikon radishes

Long, crisp white roots that look similar to carrots. They vary in length from 20 to 60cm. Unlike summer radishes, these are winter hardy; they can be stored in the ground, or lifted and stored to eat over the winter. They have a crisp, crunchy, juicy texture when eaten raw, and are equally good stir-fried.

Station sow 10 x 30cm in a traditional plot, or 20–30cm each way in beds, from mid-summer until the end of August. Harvest seven or eight weeks later, or when required, as they will keep well in the ground.

Giant red mustard.

Family: Umbelliferae (Apiaceae)

Carrots

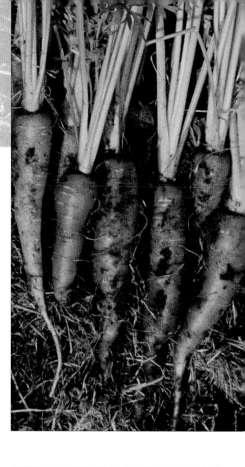

Carrots are a popular root crop, and can be eaten cooked or raw. Using different varieties you can harvest carrots almost all year round; storing roots over winter further extends the season. Carrot plants are in fact biennials, flowering in their second year, but as we eat the roots in their first year, they are grown as annuals. Leave a root or two in the ground over winter and it will produce a magnificent flower stalk that will be a magnet for beneficial insects the following year. Parsnips (see page 48) are in the same family as carrots, as are celery and parsley.

Where will they grow?

Carrots need a well-worked, stone-free soil with good structure. Grow on ground improved for a previous crop. A winter covering of autumn leaves or leafmould can create a good surface soil structure for the small seedlings to emerge through in the spring.

Growing in containers

Short- and round-rooted varieties can be grown in a wide pot or box, at least 15cm deep. Longer-rooted varieties can be grown in deeper pots or containers.

Carrots growing in a recycled polystyrene fish box with holes cut in the base.

Which variety?

- Early and main crop
- Round, short, long, cylindrical or tapering roots
- Orange, yellow, purple or white roots
- Resistant to carrot root fly

Sowing and planting

Carrots are best sown directly where they are to grow; if there is any damage to the root when transplanting they will not produce good carrots. Broadcast sow if the soil is suitable, otherwise sow into shallow drills. If the surface of your soil tends to set hard, cover the drills with a mix of soil and sand, potting compost or leafmould. Where carrot root fly is a problem, cover the soil with fleece directly after sowing.

Early varieties

The first sowings can be made under cloches or in an unheated greenhouse as early as January if the soil is at least 7°C. Sow outdoors from February through to June/July. Protect later sowings with cloches or fleece if necessary.

Main-crop varieties

Sow from April to June; late May or June for winter storage. June sowings may miss the carrot root fly.

SPACING

Traditional plot
Early varieties: sow thinly in rows 15cm apart; thin to 7cm

Main crop: 15 x 4cm; 7cm for larger roots

Beds
Thin broadcast seed to 7–15cm or sow in rows 15cm apart

A fleece covering makes an effective barrier against carrot root fly.

Crop care

Keep weed-free when young. Thin out the seedlings gradually until you reach the required spacing; young thinnings may be large enough to eat. Water the crop well before thinning if the soil is dry.

Harvesting, eating and storing

Carrots can be harvested as soon as they are large enough to eat; early varieties are ready eight or nine weeks after sowing. Younger roots are tastier, particularly if you are eating them raw. Simply loosen with a fork and pull up as many as you need, and leave the rest in the ground to grow on.

> **TIP**
> Not all carrots taste the same – try out different varieties, eaten raw and cooked, to find your favourites.

Where the soil is well drained, carrots can be left in the ground over winter and dug up as required. Protect them with a 15cm covering of straw or soil in cold areas. On heavy soils, or where slugs or carrot root fly are a problem, it is better to lift the crop for storage.

> ## Storing carrots
>
> Store autumn-harvested carrots in a box, layered with damp sand, and placed in a cool spot. Only store healthy, whole roots. Don't wash them, and twist off any foliage, rather than cutting it off.

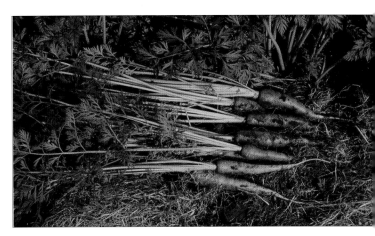

Carrots may not be successful in all soils, but can be a very satisfying crop.

Look out for: carrot root fly

Carrot root fly is a common pest that attacks carrots and also, to a lesser extent, parsnips. It lays its eggs in the soil around the crop, and the larvae hatch out and burrow into the carrot roots. An early infestation can kill the plants; larger roots will survive but may not be edible. Sowing in June can reduce the risk of attack.

Combating carrot root fly

- Grow on a windy site; the fly prefers shelter.
- Sow seeds in June, when the fly is not active, to reduce the risk of attack.
- Try resistant varieties.
- Adult flies locate carrots by scent. Avoid the need for thinning, when you might damage the foliage and release the scent, by using wide spacing when sowing. Weed and pull carrots on dry, still evenings when the scent will not spread too far.
- Growing carrots with onions (four rows of onions to one of carrots) can help minimise damage.
- Fleece gives excellent protection if used from sowing time until mid- to late June.
- Put a layer of grass mowings 5cm deep between rows of carrots when they reach 10–15cm high. This should come right up to

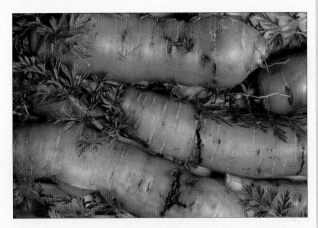

Carrots infested with carrot root fly.

the base of the plants. Top up with a further 1cm layer at weekly intervals for four weeks.
- Ridging: earth up the carrots with soil to form a ridge at least 5cm high. This may need to be repeated throughout the season to maintain a 5cm ridge.
- Lift main-crop carrots by September/October rather than leaving them in the ground over winter. Never leave crops known to be infected in the ground, where they could become a source of infection the following year.

Parsnips

Parsnips are definitely a vegetable for winter eating. Their sweet-tasting, creamy-coloured roots develop their best flavour after a frost or two, and they can be left in the ground and harvested as required. Parsnips are related to carrots, celery and parsley.

Sowing and planting

Parsnips are best sown directly where they are to grow; if there is any damage to the roots during transplanting they will not develop properly.

Parsnips are slow to germinate, and it is important to use fresh seed. They need a long growing season (sixteen weeks or more), but very early sowings are not recommended unless your soil warms up early. A slightly later sowing is more likely to succeed.

Crop care

- Keep weed-free.

Which variety?

- Shape and size of roots: some are more wedge-shaped and broad at the top; others are slimmer
- Root length
- Resistant to canker
- Suitable for growing as 'mini' vegetables

Where will they grow?

Parsnips do best on light, deep, stone-free soils where their long roots can develop well. A soil fed for a previous crop is ideal, with a mulch of leafmould or other low-nutrient soil improver if possible.

Parsnips.

Look out for:

Carrot root fly: see page 47. Generally much less of a problem than on carrots.
Parsnip canker: appears as dark brown, orange or purple patches. It is more common on acid and nitrogen-rich soils, and on poorly drained soils; early sowings are most prone. Smaller roots (grown at closer spacing) are less susceptible than larger ones. Try growing resistant varieties, and add lime to the soil, if it is acid, the autumn before sowing.

SPACING

Traditional plot
30 x 7 or 10cm, depending on size of roots

Beds
15–20cm each way
Mini veg: 6 x 15cm

Harvesting, eating and storing

For the best flavour, harvest parsnip roots after a few cold frosts, otherwise they can be harvested as soon as they are large enough. Loosen the soil with a fork before harvesting, and dig up only what you need; the roots can be left in the ground over winter. Protect them with straw or leafmould if the ground is likely to freeze hard, and mark the ends of the rows as the foliage will have died back.

Harvest by the end of February, as older roots tend to be too woody to eat, or store them indoors, as for carrots (see page 47). Parsnips can be eaten boiled or roasted, and they also make a good soup.

TIP

If you station sow seed, with two or three seeds per station, there is space in between to sow radish seeds. These will be ready to harvest long before they could hamper the parsnip growth.

Family: Poaceae

Sweetcorn

Sweetcorn eaten fresh from the plant is juicy and sweet, and a far cry from the cobs you can buy in the shops. It is a tall-growing plant, which can reach up to 180cm in a good season. Sweetcorn is frost tender and needs warm, sunny conditions, but is otherwise easy to grow. Once established, it is generally pest- and disease-free, and because it is not related to any other vegetables we grow, it can easily be fitted into a crop rotation.

Where will they grow?

An open, sunny spot with a warm soil. Grow in soil improved for a previous crop, or apply compost.

SPACING

35cm each way

Mini varieties:
15cm each way

Male sweetcorn 'flowers' are produced in tassels at the top of the plant. The female flowers are silky strands, known as silks, produced in the leaf axils, where the leaves join the stem. A single corn kernel develops at the end of each, so a whole 'hank' of silks makes up a cob.

Sowing and planting

Sweetcorn needs to be grown in a block formation, with at least twelve plants, to ensure sufficient pollination to produce good cobs. To give corn a good start, sow seed in deep modules or pots a few weeks before the first planting-out date. Plant out after the last frost, when the soil is warm. Sweetcorn can also be sown directly where it is to grow, once the soil temperature is at least 10°C. Place seed 5cm deep in light soils, 2.5cm in heavier soils. 'Super sweet' varieties should be sown at half that depth. Sow two seeds per station, thinning to one seedling.

For a quicker crop, plant the corn through holes in a sheet of black plastic, which warms the soil and speeds up growth.

Crop care

- Protect young plants from slugs and snails.
- Earth up the stems of tall varieties in windy areas for additional support.
- Water only in dry conditions, once when the plants are flowering and again when the cobs are swelling if necessary.

TIP

Plant a quick crop of lettuces between young sweetcorn plants.

Harvesting, storing and eating

Expect to harvest one cob per plant, or two in a very good year. Sweetcorn is ready to pick when the silks at the end of the cob turn brown. Test it by pressing a thumbnail into a corn grain. If a milky juice appears, it is ready to pick. Check regularly, as the crop is best eaten as soon as it is ready. Corn can be frozen, either as whole cobs or shaved from the cob.

Which variety?

- 'Super sweet', 'tendersweet' or 'sugar enhanced': bred to hold their sweetness for longer; need very good conditions to do well. Some will lose sweetness if pollinated by another variety.
- Mini varieties: only 10–15cm long
- Cob colour: yellow, white, bicoloured, blue or red
- Popping varieties: for making popcorn

Look out for:

- Slugs: control when plants are young.
- Badgers: these may eat the cobs.
- Smut: cobs become distorted, developing light grey swellings which burst to release a black powder. Burn infected plants, and do not grow corn in the same spot for at least five years.

Family: Asteraceae (Compositae)

Lettuces

Lettuces are attractive little plants that can look as good as any bedding plant. There is a choice of size, colour and shape to suit every taste and appetite. They are easy to grow all year round, if you choose suitable varieties, though slugs can be a problem. The plants tolerate light shade in the summer, and in fact prefer this to hot, dry conditions.

Which variety?

- Butterhead: traditional, plump lettuce. Leaves are juicy but not very crisp.
- Crisphead: large, solid heads of crisp leaves; includes iceberg types.
- Cos (Romaine): upright, crisp, tasty leaves, high in vitamin C and betacarotene. Semi cos types, such as Little Gem, form a heart. Slower to mature than other varieties.
- Loose-leaf: frizzy, oakleaf or curled; leaves can be picked individually, leaving the rest of the plant to grow on over a period of several weeks.
- Leaf colour: all types, including green, red and brown varieties.
- Winter lettuce: can be over-wintered outside or with protection.
- Resistant to leaf aphids and root aphids.

Lollo Rossa – a frizzy, loose-leaf variety.

A mixture of different colours and types of lettuce.

Fristina (a green, crisp non-hearting variety) and Aruba (dark red) make an attractive arrangement to rival any flowerbed.

SPACING

15–35cm, depending on size of variety

Where will they grow?

Lettuces will grow on most reasonable soils, but will not tolerate very dry or poorly drained conditions. They appreciate light shade in summer. On poor soils, add compost or other medium-fertility soil improver; on dry soils use a low- or medium-fertility soil improver to increase water-holding.

Growing in containers

Lettuces grown well in containers. It is better to grow several in a larger container, as the soil needs to be kept moist. Keep out of the sun in hot weather.

Sowing and planting

Lettuces can be sown direct. Where slugs are a problem, and for early crops, transplant seedlings from trays or modules. For a continuous crop, sow a new batch every few weeks, as most lettuces will not last very long in the ground once they have matured. Growing a range of types and varieties also helps to maintain supply, and makes for a more interesting salad, particularly if you add some of the other salads on pages 52 and 53.

For summer and autumn crops, sow seed from February to July (indoors in the cooler months); for over-wintering, sow seed in late August. Lettuce seed germination is inhibited by high temperatures (above 25°C) so summer sowings can fail. Harden off and plant out lettuces when the plants are 3–5cm tall. To extend the season, grow under cloches, in a cold greenhouse or a polytunnel.

Crop care

- Protect against slugs.
- Thin direct-sown crops gradually to the required final spacing. (Thinnings can be eaten.)
- Water in dry weather.

Harvesting, eating and storing

Most varieties are ready in ten to fourteen weeks; loose-leaf varieties in four weeks. Cut hearted lettuces as soon as you can feel a solid heart – earlier if you have grown a lot of them, as they will 'bolt' (produce a flowering stem) rapidly if left in the ground. Cut Cos lettuces, which do not bolt so quickly, whole, or remove the outer leaves as needed. You can start picking individual leaves from loose-leaf lettuces as soon as the leaves are large enough (always leaving some behind so the plant continues to grow); one plant can be picked over several weeks. Alternatively, leave plants to grow to a decent size, then cut the whole head.

Other leafy salads

Lettuce is just one of many plants that can be eaten raw or used in salads. This section introduces some of the other leafy options available. They can all can be grown in containers, and many as baby leaf crops (see page 51).

Rocket (Brassicacea)

Also known as rucola and arugula, rocket is a popular choice with upmarket chefs – and with gardeners, because it is so simple to grow. The leaves, picked when only a few weeks old, have a strong, peppery flavour. Rocket needs a soil that doesn't dry out quickly. It grows well in containers, and will tolerate light shade.

Rocket seed should be sown little and often from February to October, but may need the protection of a cloche early and late in the season. It tends to run to seed quickly in hot, dry weather, though the attractive cream and brown flowers can also be eaten, and you can save the seeds for a future crop. Broadcast sow in wide rows, as for baby leaf crops, and pick when a few centimetres tall. Water well in dry conditions.

Rocket is related to cabbages, so it is susceptible to clubroot, and very popular with flea beetle, particularly in hot weather.

Chicory is easy to grow and generally problem-free.

Corn salad (Valerianaceae)

A small, mild-tasting plant, also known as Lamb's lettuce, that used to be a weed in corn crops. A useful 'foil' for stronger-tasting salad leaves. Easy to grow all year round, it will tolerate some shade, and grows well as an intercrop between other vegetables. It is extremely winter hardy.

Sow seed direct whenever soil conditions are suitable, almost all year round. Sow in rows, or broadcast in wide drills, then thin to 10–15cm each way. It may also be started in modules for planting out, and will self-seed if you leave it to flower. Harvest whole, young plants or pick individual leaves. Corn salad may suffer from mildew in hot, dry conditions.

Claytonia (Portulacaceae)

A low-growing, annual plant, with attractive, glossy green leaves. It is also known as winter purslane and miners' lettuce. Easy to grow all year round, it will tolerate some shade, is extremely winter hardy and is generally pest- and disease-free.

Sow direct in spring for use in summer, in July and August for winter use, and in August and September for over-wintering under protection. Plants may also be started in modules for planting out, thinning to 10–15cm each way. Claytonia will self-seed if left to flower.

Rocket.

Pick individual leaves over several weeks, or cut whole plants. The leaves, stems and flowers are all edible and have a pleasant, mild flavour.

Corn salad.

American landcress (Brassicaceae)

A hardy, dry-land version of watercress, with a hot, spicy flavour. It can be picked over many weeks, starting 8–10 weeks after sowing.

Landcress needs a moist, humus-rich soil; it will grow in damp, shaded locations in summer where not much else will thrive. It also grows well between taller crops if the soil doesn't dry out. Water plants in dry weather, and protect them over winter.

Sow seed from March to June for picking in the summer; July and August for cropping over winter and into spring. Sow in rows 15cm apart, thinning plants to 10cm apart in each row. Pick individual leaves when they are large enough.

Landcress is a member of the brassica family, but its only real pest is the flea beetle.

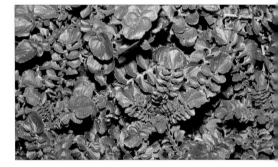

American landcress.

Endive (Compositae)

Endive is an easy-to-grow, useful salad crop related to dandelion and chicory. Its slightly bitter tang can be an acquired taste, but you can reduce the bitterness by blanching plants individually before use. This is done by covering them with a light-proof bucket or a large plate, for ten days or so. There are Frizzy types with curly leaves, and hardier, broad-leaved (Batavian) types, both growing as a rosette rather than a head. Endives can also be grown as baby leaf crops.

Sow seeds in spring and summer for harvesting in summer and autumn. Protect the plants early in the season, as they may run to seed quickly if temperatures drop below 5°C. Space plants 23 x 30–35cm in traditional plots, or 25cm in beds. The plants should be fully grown three months or so after sowing; you may need to protect them from slugs.

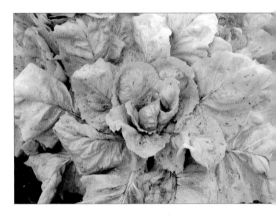

Chicory, Variegata di Castelfrano.

Chicory (Asteraceae)

Chicory is easy to grow, being generally problem-free and tolerant of both cold and drought. It can be sown at almost any time of the year. Pick the leaves as required, or grow it as a baby leaf crop. There are many varieties to choose from. Some form a hearted head, like a lettuce; when cut, the stump may regrow new leaves. Red chicory, also known as Radicchio, adds colour and a slightly bitter flavour to a mixed salad.

Sow seed, 20–30cm each way, from mid-spring to autumn; early spring sowings are best made in modules for transplanting later. Baby leaf seedling crops can be sown at any time of the year, if given some protection.

Chopsuey greens (Brassicaceae)

Also known as shungiku, or the edible chrysanthemum. The leaves have a strong, aromatic flavour that is not to everyone's taste. Seedlings and young shoots can be eaten in salads or stir-fries. Sow seed from May to July outdoors, and in September under protection. If you find you don't like the flavour, leave the plants to flower. The yellow, daisy-like blooms make beautiful cut flowers.

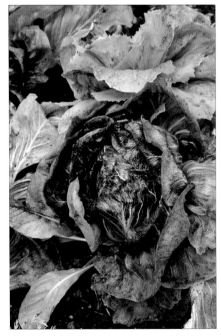

Chicory, Radicchio variety

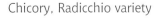

Family: Alliaceae

Onions, leeks, garlic and shallots

Bulb onions, leeks, garlic, shallots and spring onions are all easy-to-grow, hardy crops. The sweeter-tasting shallots are probably the easiest of all to grow, and are less prone to disease. Onions, shallots and garlic store well over winter and into the following spring, and leeks can be left in the ground to be dug over many months. Spring onions can be harvested in as little as eight weeks from sowing.

Which variety?

Bulb onions
- Autumn or spring start
- Red or yellow skinned

Garlic
- Autumn or spring start
- Size of individual cloves
- Short and long keepers

Leeks
- Early and late season
- Colour of foliage: some have purple foliage
- Resistant to rust

Shallots
- Autumn or early spring start
- Brown or red skinned
- Round or oval

Spring onions
- Main season and winter-hardy varieties
- Red or white skinned

Onions growing in rows.

Sowing and planting

Bulb onions

The easiest way to grow bulb onions is from sets – 'mini' onions that are planted to grow into larger onions. Plant them so that the tip is just showing above the ground. Plant sets in spring for late summer cropping; autumn varieties are planted from September to November to be ready the following July.

Bulb onions can also be grown from seed, sown either direct in early April, or in modules in early spring for transplanting. Sow autumn varieties in August.

Where will they grow?

Members of the onion family will grow on most reasonable soils, as long as they are well drained. Keep the ground weed-free if possible. Soil improved for a previous crop should be rich enough, though leeks will benefit from well-rotted manure or compost, particularly on light soils.

Multi-sown red onions (see page 21).

Leeks are easy to grow and can be harvested through the winter.

Shallots

Sow seeds in March or April, or plant sets in autumn or spring depending on the variety.

Garlic

The best time to plant garlic is in the autumn, though on heavy soils that tend to be very wet over winter spring is better. Plant individual cloves so that the tip is 2–3cm below the soil surface. Use certified, virus-free planting garlic rather than garlic bought from the greengrocers – most garlic sold for eating is imported, and the varieties may not suit the UK climate.

> **TIP**
> Individual garlic plants take up little space and can easily be fitted into an ornamental border.

Spring onions

Sow seeds every few weeks throughout spring and summer for a continuous supply. Winter-hardy varieties can be sown in August for an early spring crop.

Leeks

Sow rows of seeds in a seedbed from March to early May. Alternatively raise plants in modules from February, transplanting them to their final growing site when they are at least 20cm tall. Transplant leeks by dropping them into 15cm deep holes, made with a dibber. There is no need to fill in the hole – simply fill the hole with water after planting.

Crop care

Keep weed-free. Leek plants should be watered in at planting and when the weather is dry. There should be no need to water onions, shallots or garlic.

Harvesting, storing and eating

Bulb onions

Onions are usually left to grow to maturity, which is when the leaves fall over, though they can be eaten fresh from the ground as soon as they are large enough. Once the leaves have fallen over, leave the plants in the ground to dry off (you can gently lift and replace them

SPACING

Bulb onions:
Traditional plot
10 x 30cm

Beds
15–25cm each way

Leeks:
Traditional plot
7.5–15 x 30cm

Beds
1.5 x 15cm for 'mini' leeks; 15 x 15cm for medium-size leeks

Garlic:
Traditional plot
7.5–10 x 25–30cm

Beds
15–20cm

For onions, leeks and garlic, adjust spacing depending on final size required.

Shallots:
Traditional plot
15 x 20cm

Beds
20cm

From seed: sow seed thinly in wide drills, aiming for 2–3cm between plants.

Spring onions:
Sow seeds thinly in rows 10cm apart, aiming for 2–3cm between plants.

Storing onions

If you intend to store onions over winter, they should be 'rustle' dry. Onions planted in the autumn should keep in store until the end of the year; spring-planted onions may last six or seven months in store if they are well dried in the autumn. Plait them into strings, stuff them into stockings or tights, or lay them out in a single layer on a slatted tray. Keep them in a cool, airy, frost-free location.

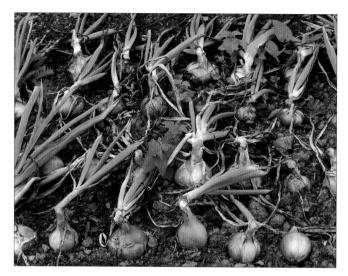

Yellow-skinned onions. Allow the tops to fall over naturally as the plants mature.

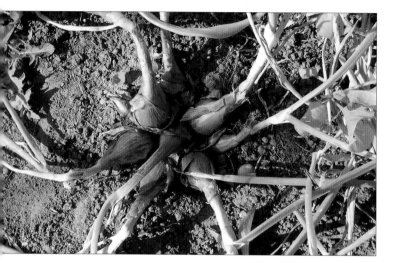

to break the roots). If the weather turns wet, lift the drying onions and lay them out in a single layer in an airy, sunny location. An old bed frame is ideal for this, allowing good air flow all round.

Shallots

Shallots are usually ready a few weeks before bulb onions. Dry them off and harvest in the same way, and store them in a shallow basket or tray in a cool, airy place.

Garlic

Garlic should be harvested when five or more leaves have begun to turn yellow. Any later than that and the quality of the wrapping skin may deteriorate and the stem come away from the bulb, though it will still be edible. Dry them off as for onions, then tie them into strings and store in a cool, airy place.

Spring onions

Harvest and use them fresh when about the thickness of a pencil.

Leeks

Leeks can be harvested as soon as they are large enough. Main-crop varieties can be left in the ground over winter and harvested when required. They can also be frozen.

Each shallot you plant will produce a clump of new shallots.

Look out for:

- Onion fly: the larvae of this fly attack the underground parts of all members of the onion family. Growing the plants under mesh or fleece is the only way to protect them from this pest.
- Onion downy mildew: this disease attacks onions, shallots and chives. The leaves develop a grey/purplish mould and die back. This disease is widespread in cool, wet summers. The best way to protect your plants is to use a five-year crop rotation and avoid over-feeding them.
- White rot: a disease that attacks the roots of onions and necks of garlic. It causes the roots to rot, and a white, fluffy mould may be present. The disease can last for twenty years or more in the soil, so use as long a crop rotation as possible. Leeks may sometimes grow where onions and garlic fail.
- Leek rust: rusty red pustules develop on the leaves in late summer. These may disappear if the weather turns cold or wet. Reduce the risk of infection by watering plants in the summer if it is dry.
- Garlic rust: there is nothing that can be done about this disease, but it usually looks worse than it is!

Leek rust.

Family: Solanaceae

Potatoes

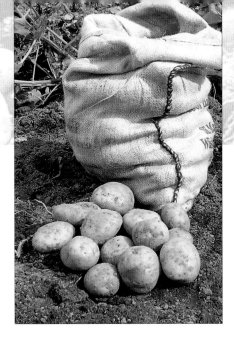

The potato has undergone something of a revolution over the last few years, fighting back against pasta and rice as a staple food. It is easy to grow and good value, a good source of vitamin C, and can be cooked in many different ways. Gardeners now have a choice of over a hundred varieties, from the floury, blue-skinned Edzell Blue, which makes a wonderful white mash, to the reliable all-rounder Kestrel, and the gourmet waxy salad potatoes. Potatoes are grown from 'seed potatoes', which are specially produced to ensure freedom from pests and disease. Many varieties are available as organically grown 'seed'.

Which variety?

Length of growing time needed to produce a good crop

- Early, second early/early main crop, main crop. Early varieties can crop ten weeks from planting, though yields are quite low. Main crops generally have the highest yields, and are the best varieties to store, cropping around fifteen weeks from planting.

Cooking and eating qualities

- Waxy: low in starch, and keep their shape well when cooked. They are good for boiling and salads, but make a poor mash.
- Floury: high starch content, so good for mashing, frying, baking and chips. They tend to disintegrate when boiled, so steaming is preferable.
- Multipurpose: have a texture somewhere between the extremes of floury and waxy and can therefore be used for all purposes.
- New: young tubers harvested early in the season. They have thin skins, and are often waxy in texture.

- Bakers: large potatoes, either waxy or floury. Smaller potatoes are good for baking too.

Skin and flesh colour

- Red, white, yellow, blue, pink, bicoloured, purple or black skinned. The flesh is generally white or yellow, though some of the old varieties have coloured flesh too.

Pest and disease resistance

- Varieties are available with some resistance to the major potato pests and diseases, including potato eelworm, slugs, late blight, scab and blackleg.

Cara: a late main crop; high yields and good disease resistance; white skin with red eyes; a good all-rounder in cooking.

Tuber size

- This will vary with growing conditions, but some varieties naturally produce fewer, larger tubers than others.

Cosmos: a second early crop; blight resistant; multipurpose cooker.

Salad Blue: a second early crop; purply-blue skin and blue flesh; makes excellent mash and chips.

Sowing and planting

Buy seed potatoes early, in January or February if possible, and set them out in boxes or egg trays to grow small shoots. This is known as chitting. Set them with the 'rose' end upwards (this is the end where you will see a cluster of tiny buds). Put them in a cool, light, frost-free place until you are ready to plant them.

Chitting seed potatoes.

Potatoes are generally planted from mid-March to May, when the soil conditions are right. Potato shoots are frost tender, so don't plant them too early unless you are able to protect them from frost, for example in a greenhouse, in covered pots or under fleece.

Planting potatoes

Potatoes can be grown in various ways:
* Trenches: dig trenches about the width and depth of your spade. Place an organic soil improver in each trench; cover with a thin layer of soil then place the potatoes in, sprouts upwards, so the tip of each tuber is about 15cm below the surface. Carefully fill in the trenches.
* Individual holes: add a soil improver to the soil before planting. Dig individual holes using a trowel, and plant the tubers 15cm deep.
* 'No dig' method: spread a soil improver/fertiliser over the area to be planted. Place seed potatoes on the ground and cover with a layer of straw, approximately 15cm thick. Add more straw as the potato shoots grow. Finally, cover the straw with a thick layer of grass mowings to keep out the light.

SPACING

Traditional plot	Beds
Early: 30 x 45cm	Early: 30cm
Second early and main crop:	Second early: 35cm
38 x 65–70cm	Main crop: 40cm

Crop care
* Protect against frost early in the season.
* Keep weed-free.

Where will they grow?

An open, sunny spot is best, though potatoes will tolerate some shade. The ideal soil is a well-worked, slightly acidic, fertile soil, rich in organic matter, with good drainage. Potatoes will produce a small crop in poorer soil, as long as it is well drained. They can even be planted in weedy ground to help clear it – once they have been planted, earthed up and then harvested, the weeds will be much reduced.

Before planting, apply composted manure or other nutrient-rich soil improver, or, on light soils, use a nitrogen-rich organic fertiliser with added leafmould or other low-fertility soil improver.

Growing in containers

A good way of growing portatoes if you are short of space, and of producing out-of-season crops. Early varieties are the best choice. Plant one tuber in a 10-litre pot; three to five in a 40-litre pot or tough, polythene potato bag. Put a 10cm layer of crocks or chunks of polystyrene in the bottom to help drainage. Plant the tuber (or tubers) in a 15cm layer of good potting compost. Add more compost as the shoots grow, until the pot is almost full. Water regularly.

Second cropping

For a second crop, any time from October to the end of December, buy seed potatoes sold specifically for late planting. They are usually available in July and August. Grow in the ground or in pots; you will need to protect the plants from frost.

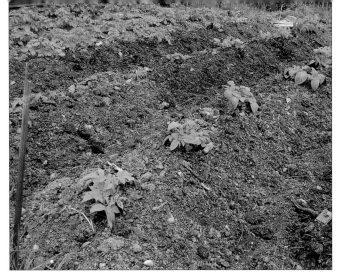

Earthing up

Earthing up

Earthing up or mulching a crop can help control weeds, prevent tubers near the surface turning green, and give them some protection against potato blight.

Watering

There is generally no need to water potato crops unless the weather is very dry. The best time to increase yield is when the forming tubers are the size of marbles. This usually coincides with flowering. Potatoes in pots will need regular watering.

Harvesting, eating and storing

Potatoes can be harvested as soon as they are large enough to eat. For the biggest crop, wait until the tops have died down naturally if possible, then complete the harvest by mid-September; earlier if slugs are a problem. Harvesting is best done on a cool, dry day, so you can leave the tubers on the soil surface for a few hours to dry off. Potatoes often taste better if left for a day or two after harvest.

Potatoes dug in late summer can be stored for many months in a cool, dark place; store second early and main-crop potatoes in thick, brown, paper sacks. Place healthy, undamaged tubers gently in the sacks, then store them in a cool, frost-free, mouse-free location.

Earth up second early and main-crop varieties several times as the shoots grow. Start when they are around 15cm tall, leaving a few centimetres of shoot showing; stop when it becomes impractical. Alternatively, mulch between the rows, with grass mowings, leafmould, hay or straw.

TIP

Take care when digging up potatoes. Put your fork vertically into the soil, 30cm or more from the main stem of the plant, push the handle down gently and a clump of potatoes will appear. It is worth digging each row twice to make sure all the potatoes are harvested.

Look out for:

- Potato blight: a common potato disease. Brown blotches appear on the leaves in warm, wet weather and can rapidly spread over all the foliage. If this happens, cut off all the potato tops and put them in the compost heap. Don't harvest any tubers for three weeks. If you notice potatoes almost at the soil surface, mulch the rows with leaves or straw, or even cover them with more soil, to prevent the tubers going green (which makes them inedible). Where blight is a regular problem, try growing more resistant varieties, or grow early varieties which should give a decent crop before blight strikes.
- Scab: unslightly, but potatoes can be peeled and eaten. It is most common on dry and alkaline soils. Grow resistant varieties, improve the soil, and never add lime before a potato crop.
- Slugs: these can tunnel into potato tubers, making them inedible. Some varieties are more resistant than others. Where the problem is severe, apply nematodes to the soil (see page 29).

Potato blight.

Potato scab.

Family: Solanaceae

Tomatoes

The taste of a ripe, juicy, home-grown tomato cannot be matched by any shop-bought ones. Tomatoes in the shops are picked before they are ripe, and never develop such an intense flavour. Tomatoes are relatively easy – and fun – to grow, in pots or in the ground, but they do need warm conditions, particularly at the start.

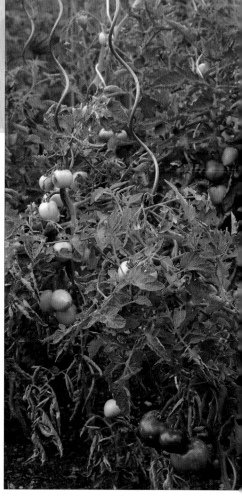

Tomatoes growing up spiral supports.

Which variety?

Fruit

- Colour: red, yellow, orange, pink, striped, green, white or almost black.
- Size: tiny, bite-sized cherry tomatoes through to giant 'beefsteak' varieties – thick walled and juicy, these are great for salads and cooking.
- Plum tomatoes: these have thick walls and are less juicy, so they are ideal for tomato sauce, but they can be quite late to ripen.

Plants

- Bush and tumblers (dwarf plants): good for pots, and even hanging baskets. There is no need to give them support, or to remove side shoots.
- Cordons or indeterminate: these plants keep growing until they are stopped; in commercial greenhouses they can grow as much as 12m in twelve months! They are usually allowed to go to 1.5–2m, then the tip is pinched out. Side shoots are removed, and they do need support.
- Semi-determinate: large, bushy plants that need some support, but no need to remove side shoots.

Greenhouse or outdoor

- Some varieties are suitable for either greenhouse or outdoor growing; others can be grown in a cool greenhouse and outdoors.

Gardener's Delight.

Where will they grow?

If grown outdoors, tomatoes need a warm, relatively sheltered spot, in full sun. If planting in to the soil, either outdoors or in a greenhouse or polytunnel, apply garden compost to the planting holes or over the whole area to be planted.

Growing in containers

Tomatoes can be grown in 20–30cm pots or in growing bags. Pots are easier to look after, particularly with regard to watering. Use a rich, peat-free potting mix.

Sowing and planting

Sow seeds under cover, at a temperature of 16°C, six to eight weeks before the last frost. Sow in module trays or a seed tray, then prick out into 10cm pots. Keep the plants somewhere light and warm until they are ready to plant out, which is when the first flower buds appear.

Shop-bought plants should be potted up into 13cm pots. When the first flowers open, pot them into their final growing container. If planting into soil, harden them off before planting out once the soil has warmed up to at least 10°C and all danger of frost has passed. Protect with fleece or cloches if necessary.

Crop care

Indeterminate varieties, grown in a greenhouse, can be trained up strings from the roof. Tall plants grown outdoors can be tied to a stout stake or trained round a spiral support. Dwarf varieties do not usually need support.

Once fruit have formed, water plants that are growing in the ground, but only in really dry weather. Too much watering, particularly early on, encourages leafy growth rather than fruit. Plants in containers will need more regular watering; in hot weather, a large plant with lots of fruit will need watering at least twice a day.

Plants growing in the ground should not need extra feeding. If the soil is not very fertile, mulch the plants with garden compost or other medium-fertility soil improver. Plants in containers should be fed with a liquid organic tomato feed once the fruit begin to set, but not before. In general, over-feeding is much more likely to cause problems than underfeeding.

In late summer (earlier in cooler areas), pinch out the growing point of indeterminate varieties to stop them growing and to encourage the existing fruit to develop and ripen before the warm weather ends.

Harvesting, eating and storing

Pick fruit when they are fully ripe for maximum flavour. At the end of the season, semi-ripe fruit can be picked and brought inside to continue ripening.

SPACING

Cordons/indeterminate:
45 x 45cm

Semi-determinate:
45 x 60cm

Dwarf bush:
30 x 35cm

Consult the seed packet for specific information on spacing.

Pinching out

Indeterminate varieties are grown as a single stem, so pinch out (or cut) the side shoots as the plant grows.

Look out for:

- Tomato blight: caused by the same fungus as potato blight. Affects fruits, stems and leaves. Infected fruits develop leathery, brown patches, which may not appear until after the fruit has been harvested. There is no treatment or cure. Where this is a regular problem, grow small-fruited varieties that may produce a crop before the disease occurs. Some resistant varieties are available, but may not be very effective.
- Blossom end rot: fruits develop a dark brown, leathery, sunken patch where the flower was attached. This is caused by inadequate or irregular watering, so it is usually only a problem of container-grown plants. Water plants regularly to avoid this problem.
- Whitefly: in a greenhouse or tunnel, interplant tomatoes with French marigolds to reduce risk of whitefly attack, or use biological control.

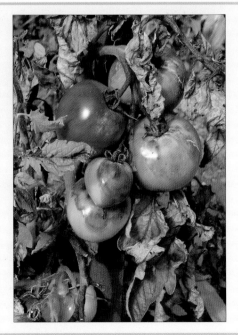

Tomato blight.

Courgettes, pumpkins, squashes and marrows

These vegetables are all closely related. They produce fruits on large, striking plants, some of which trail or scramble many metres – try growing pumpkins so they trail through a sweetcorn bed, or climb up a hedge or trellis. Bush varieties can look good in an ornamental border. These frost-tender vegetables are easy to grow as long as the weather is warm and sunny enough.

Which variety?

Courgettes
- Colour of fruits: dark, mid- or light green, or yellow
- Resistant to cucumber mosaic virus
- Pollination not needed to set fruit: good for growing in a greenhouse or under cloches, or if you have only one plant.

Marrows
- Green, striped or yellow
- Bush or trailing habit

Squashes and pumpkins
- Trailing or large bush
- Summer or winter use
- Variety of shapes and sizes
- Skin colour: various
- Flesh: various colours, textures and flavours

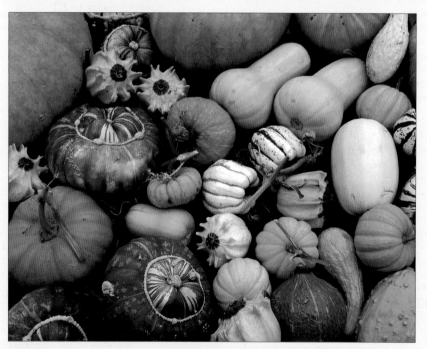

Squashes and pumpkins come in a wide variety of shapes, sizes and colours. Summer squashes are thin-skinned and ready for eating in summer and autumn; winter squashes and pumpkins have a much denser flesh, often with more flavour, and are full of vitamins. They are eaten when fully ripe in the autumn. They can be stored for many months, or even years.

Where will they grow?

Plants in this family need a warm soil in a sunny spot, well sheltered in cooler areas. Feed the soil with a low- or medium-fertility soil improver, depending on the condition of the soil. On light soils, improve water-holding. Avoid over-feeding, as this tends to result in larger, leafier plants with no increase in the size of the crop.

Courgettes can be grown in a greenhouse, polytunnel or under cloches for an earlier crop. For cropping under cover, choose a variety that does not need pollination.

Growing in containers

These vegetables are not really suited to growing in containers, but courgettes will cope in a large pot or growing bag.

SPACING

Courgettes and marrows: Traditional plot
Bush: 60–90 x 90cm
Trailing: 90 x 180cm

Beds
Bush: 75–90cm
Trailing: 120cm

Pumpkins and squashes: Traditional plot
Bush: 90 x 120cm
Trailing: 120–180 x 180cm

Beds
Bush: 100cm
Trailing: 120cm

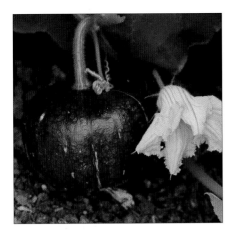

Kabocha squash (top) and Crook Neck squash (right) with flowers.

Sowing and planting

Raise plants in large modules or 9cm pots. Sow in a warm place in April or May, no more than three weeks before planting out. Plant out after the last frost, when the soil has warmed up, and when the plants have just three or four leaves.

In mild areas, seed can be sown direct outside from early summer onwards. Protect the plants with cloches for extra warmth at the start. Courgettes can be sown from early March for growing in a greenhouse, as long as they are protected from frost.

Crop care

- Protect young plants from slugs and cold weather. Water them until they are well established, then mulch with moisture-retaining material once they are growing well.
- Courgettes may need watering when they start to crop; pumpkins and squashes need little, if any, additional watering.
- Trailing varieties can be trained round in a spiral, coaxed up wide mesh netting, or simply left to grow where they want.

Harvesting, eating and storing

Pick courgettes when they are around 10–20cm long by cutting them off the plant with a sharp knife. Check plants daily in warm weather, as a small courgette can rapidly turn into a large marrow! Pick summer squashes and marrows that are not for storage when they reach the required size. If you intend to store them, marrows, pumpkins and winter squashes should be left on the plants as long as possible in the autumn to allow the fruits to ripen and develop a tough skin. Harvest before the first frost, leaving as long a stalk as you can, then, if possible, leave in a warm, sunny spot for a week or two for the skins to set. Check for skin blemishes, and store in a dry, airy place, preferably on slatted shelves or hanging in nets. Eat or freeze any that show signs of damage or disease.

Pumpkins and winter squashes flesh can be frozen in cubes or slices, either raw or cooked. Pumpkin-based soups and curries also freeze well.

Pollination

Pumpkins, squashes, courgettes and marrows produce large, striking, yellow trumpet flowers.
Male and female flowers grow separately on the same plant. Female flowers have a tiny fruit at the base; male flowers produce pollen which must be transferred to the female flowers (usually by bees) for the fruit to develop. Early in the season, a plant may produce only female or only male flowers. This problem usually corrects itself naturally, but growing more than one plant can help to ensure pollination. A few varieties, such as Parthenon, produce fruit without pollination.

Look out for:

- Slugs and snails: may damage or kill young plants in cool, damp weather.
- Powdery mildew: forms a powdery white coating on leaves, usually at the end of the growing season when it is not a problem. If it appears earlier, water the plants well if the soil is dry.
- Cucumber mosaic virus: can be a major problem for courgettes. It tends to appear on plants once they have started to fruit. The young leaves develop a mottled yellowing, growth is reduced and the leaves are distorted. Fruit tends to be pock marked and cropping will be poor. Infected plants should be pulled out and put in the compost heap. Try growing resistant varieties to avoid this disease.

Index